Why We Need the Arts

8 Quotable Speeches by Leaders in Education, Government, Business and the Arts

From the 1988 National Arts Convention, cosponsored by the American Council for the Arts and the New Jersey State Council on the Arts/Department of State

ACA BOOKS
American Council for the Arts
New York, New York

The 1988 National Arts Convention was cosponsored by the American Council for the Arts and the New Jersey State Council on the Arts/Department of State and was underwritten by the generous support of AT&T, the Geraldine R. Dodge Foundation, Johnson & Johnson, Mutual Benefit Life Insurance Company, Schering-Plough Corporation, Merck & Co., Inc. and Bell Atlantic.

Jacket design: Joel Weltman, Electric Pencil Studio
Book design: Robert Porter
Printing by Bookcrafters, Inc.

Director of Publishing: Robert Porter
Assistant Director of Publishing: Sally Ahearn

Library of Congress Cataloging-in-Publication Data

National Arts Convention (1988: New Brunswick, N.J.)
 Why we need the arts.

 "From the 1988 National Arts Convention co-sponsored by the American Council for the Arts and the New Jersey State Council on the Arts/Department of State."

 1. Art patronage—United States—Congresses. 2. Arts—United States—Congresses. I. American Council for the Arts. II. New Jersey State Council on the Arts. III. New Jersey Dept. of State. IV. Title.
NX705.5.U6N36 1988 700'.973 89-6698
ISBN: 0-915400-79-0

This publication has been made possible by the generous support of the New Jersey State Council on the Arts/Department of State, Schering-Plough Corporation, and Merck & Co., Inc.

Contents

Welcoming Remarks from the National Arts Convention

Alvin S. Felzenberg, Assistant Secretary of State, New Jersey

Situated between New York and Philadelphia, New Jersey is, as Benjamin Franklin said, "on the whole, much like a keg of ale tapped at both ends." One of the foremost goals of the Kean Administration has been the restoration of New Jersey's identity and pride, and the arts have played a vital role in achieving that goal. Since taking office in 1981, the Governor has challenged our arts organizations to become "second to none," and he has consistently provided them with the resources to do so, by recommending major increases to the New Jersey State Council on the Arts' budget. That budget has risen by more than $20 million, to just over $23 million in the current fiscal year. The Governor's Excellence Initiative in the Arts provides $7.5 million for our best arts organizations and artists, and the Artistic Focus program rewards those arts organizations that show potential for national prominence.

In fact, the Artistic Focus Awards are perhaps the best illustration of the Governor's charge. Reflecting his priorities, early in his term the Governor transferred responsibility for the arts to the Secretary of State, giving the governor a cabinet-level advocate for cultural affairs. He then asked that the State Arts Council create opportunities for New Jersey's strongest arts organizations to attain national prominence in their disciplines. After four years, the Artistic Focus designation is the most prestigious recognition bestowed by the Arts Council. Eight arts groups, as diverse as the Newark Museum, the New Jersey Symphony Orchestra, WBGO Radio, the Montclair Museum, Crossroads Theatre, the McCarter Theatre, Paper Mill Playhouse, and the New Jersey Chamber Music Society now receive more than $3.2 million in support from this source.

The State Arts Council, through the direction of Jeff Kesper and the diligence of current Council members, has become a well-managed and highly professional resource for artists and arts organizations in New Jersey. I know that you will enjoy meeting members of our great arts community. On behalf of Governor Thomas H. Kean and of Secretary of State Jane Burgio, it is my pleasure to welcome you to New Jersey for this very important 1988 national arts convention.

Jeffrey A. Kesper, Executive Director, New Jersey State Council on the Arts

Over the past six years, we have had what I would call a quiet revolution in the arts in New Jersey. During that time—the tenure of our present governor, Thomas H. Kean, and of Secretary of State Jane Burgio, and, as good fortune would have it, during my own tenure as executive director of the New Jersey State Council on the Arts—we have seen the Council's state appropriation increase from $3 million to $23 million for fiscal year 1989. This dramatic expansion has moved us from number 28 in state support of the arts nationwide, to number two. This expansion—and I assure you that we do not take this growth or these numbers for granted—reflects high-level arts policy for our state. It also reflects long-range planning, diligence and hard work on the part of the Arts Council and the arts community.

The story of the arts in New Jersey—the quiet revolution I spoke of—is a story of planning. At the beginning, in 1966, our arts council was typical: we had a two-person staff and a $75,000 appropriation. It took 12 years for our budget to top $1 million (in 1978). And it wasn't until 1983 that the Council recognized the need for a long-range plan. Now, midway through our five-year plan for 1986-1990, we are beginning to see the outcome of our planning and our vision, and it is extremely rewarding and remarkably on target.

One thing that became evident through our planning process was the fact that our citizens care about the quality of life. Improving the quality of life became a priority for both the state administration and the Arts Council. In 1987 our voters passed a "quality of life" bond referendum that appropriated $100 million to improve important features of New Jersey. Forty million dollars of that total was earmarked for the construction and capital improvement of our state's cultural centers, which were felt to be crucial, to both the cultural and economic revitalization of our state.

Many of the concerns of this convention are concerns we have also heard expressed in our own state and have worked hard to resolve. One of these concerns is arts education.

Like so many others have done, our Arts Council determined that arts education was a priority, and we began to address this issue in our state. Today, with a "Literacy in the Arts" task force established by the Governor and by the state legislature, we are

just beginning to see the fruits of our shared labors. The Arts Council's own arts education programs, abetted by a planning grant from the National Endowment for the Arts, have recently expanded to include a new state grants program which will bring together arts organizations and educational institutions to enable them to develop programs that can be part of the core curriculum in our schools. Our Artist/Teacher Institute, which just concluded its 13th season, is already well-known as a national model for teacher training.

The concern of this convention for the well-being of the individual artist is also shared by us here in New Jersey. We have attempted to make an impact on the state's artistic environment by increasing substantially our Individual Artist Fellowships, and the artists have responded positively.

And, because we know that in order for artists to thrive they must live in an environment with opportunities to exhibit and to perform, our State Arts Council sponsors Fellowship Exhibits and performance showcases, crafts exhibits and poetry reading series, and works with six of our state's outstanding museums to sponsor an Arts Annual to exhibit some of our state's finest visual art. We continue to engage individual artists in our artist-in-residence programs in schools and in our Art in the Parks summer programs as well.

We have also attempted, as many of you have done, to support our individual artists and, at the same time, to satisfy the need for art to be publicly accessible through our "Arts Inclusion" program (known as "percent for art" in some states). Some 70 public art commissions and projects are either completed or in progress in New Jersey, worth nearly $4 million.

The concern of this convention for the development of cultural relations abroad and of our indigenous cultures and their arts is also a concern we are addressing. Our arts community has worked hard to lessen urban/rural and north/south tensions and to respond to the needs of our ethnically diverse arts communities by taking the initiative in both areas. Our Minority Arts Initiative is designed to provide technical assistance in management and board development, professional consulting and audience development to artistically sophisticated groups who can benefit from such support. A parallel program of development and technical assistance is available to arts groups in our mostly rural southern counties, where the needs are different but equally critical.

We feel very strongly about the issues we will face together at this convention. Like every state with a heterogeneous population, with both rural and urban (and in our case, suburban) areas and concerns, with very affluent and very poor people and neighborhoods, New Jersey faces issues of critical importance. Because these issues engage our artists and arts organizations and arts administrators at every level, from policy making to daily life, we are—as you are—continually involved, continually looking for new questions and better answers.

Tourism is New Jersey's number one industry, and the arts are an integral part of that industry. The State Arts Council supports directly with its funding 38 orchestra and music ensembles, 28 professional dance and theatre companies, 26 museums and galleries, 20 county arts agencies, and scores of individual artists. In addition there are over 400 local arts organizations that we support through our county partners. According to recent census figures, New Jersey has some 48,000 professional artists. Last year, we in New Jersey attended more than 75,000 performances and presentations across the state. Audiences of more than 11 million people saw, heard or participated in the arts. Ours is a rich state—ethnically, historically, economically and culturally.

I am personally looking forward to the give-and-take of this convention. This is a great opportunity to make some contribution as a group to the ongoing development of American culture. The issues and concerns that each of us in our individual states have tried to address are now before us again at this convention. None of us has all the answers, and we have much to learn. My hope is that by listening to each other, and by sharing our best ideas and solutions, we can move toward a revitalized national arts community in the 1990s.

From all of us at the New Jersey State Council on the Arts, welcome to New Jersey. Enjoy the excellence of New Jersey arts.

Introduction

Milton Rhodes, President, American Council for the Arts

The 1988 National Arts Convention was an extraordinary three-day expedition in search of "the road ahead." We were privileged at that event to hear from some of the most articulate, caring, enlightened, and thought-provoking spokespeople for the arts. Leaders in education, government, business, and the arts showed us what creativity is and where it resides—in virtually every sector of our society.

The American Council for the Arts is proud to make available the full texts of the speeches presented at the 1988 National Arts Convention. We are witnessing a new era of conversation among all parties is this broad field called the arts. These speeches raise the intellectual level of that conversation. They leave no question as to why we need the arts.

To Answer the Hunger Within

Governor Thomas H. Kean

I love the arts—the great inspiration of an afternoon at a museum, the thrill of a great musical performance, or the excitement of a magical evening at the theater. By training and vocation I am an historian, and I believe nowhere in history is there a civilization we admire whose people have not valued the arts.

We are brought together at this convention by a compelling truth, said best by the master painter Degas. One day in Paris, Degas was accosted on the street by another painter, a man named Vibert, who said, "You must come to see our exhibition of watercolors."

Degas was dressed shabbily, as usual, and as a bit of a dig, Vibert added, "You may find our frames and rugs a little too fancy for you, but art is always a luxury, isn't it?" Degas replied, "*Yours* may be, but *my* art is an absolute necessity." Today, few people have ever heard of Vibert; few have not heard of Degas.

Art is indeed an absolute necessity, an essential part of life. The skeptic might disagree. He would point to food, shelter and clothing as the true essentials. But art provides the food, shelter and clothing of something within us, something that has always been

Governor Thomas H. Kean has served as governor of New Jersey since first being elected to office in 1981. He is a member of the executive committee of the National Governor's Association and has served as chairman of the Education Commission of the States. Newsweek *magazine has called him one of the Nation's five most effective governors.*

"Art is indeed an absolute necessity, an essential part of life. . . . My point is very simple—if food and shelter give us life, art gives us something to live for."

there and must be satisfied as surely as our stomachs. My point is very simple—if food and shelter give us life, art gives us something to live for.

But forgive me. When I say that art is essential to man's happiness, to every society's growth and health, I know I am preaching to the converted. You share my passion in this regard: that is why you are here. You are the bearers of the flame. Still, this basic message, this fundamental truth, cannot be repeated too loudly or too often.

Prehistoric man felt its importance, mixing blood and clay to paint the walls of his caves. What was true in the days of the Mastodon, what was true in the age of the Medicis, is still true today. If anything, art has gained in its importance as civilization has progressed from arrowheads to warheads.

After all, art is the ultimate ambassador. Even before there was glastnost, art could bring an American crowd to its feet to applaud the Moscow Ballet. Art is the passport that opened Soviet Russia to Vladimir Horowitz— and to Billy Joel, for that matter. Art is the proof that genius has no race or nationality, no ideology or class. What better example of the universality of art than the grande finale of virtually every 4th of July concert: Tchaikovsky's *1812 Overture?*

If art has this power, then the other compelling truth that brings us together is the duty every member of a society has to support the art that represents it. In ancient Greece your oath of citizenship included a pledge to make

the society a better place through your efforts. Today it is no less our duty, as elected officials, as business leaders, as parents and citizens, to make our society a better place. We do that by supporting the arts.

That is why I am so proud of New Jersey's accomplishments in this area. I am proud that right-minded public servants like Maureen Ogden and John Lynch could sponsor legislation, calling it the Quality of Life bond initiative, that included $40 million for the repair, restoration and construction of arts facilities throughout the state. I am proud that the people of New Jersey responded in kind, voting two-to-one in favor of the bond.

I am proud that as Governor I have increased the arts budget from $3 million to $23 million, and that 19 state properties throughout New Jersey are now graced by art-in-public-places projects.

I am proud that we have established our Governor's School for the Arts at Trenton State College to nurture our best student artists. I am proud of our Folk Artists in the School Program, and of how we've established artists residencies in schools in every county.

I am proud of one more thing, too: our creation of a Literacy in the Arts Task Force, headed by Ernest Boyer. In the next year, this panel will create a plan for the development of arts education in every elementary and secondary school in New Jersey. Among other things, it will develop new curricula and identify model programs.

" . . . the other compelling truth that brings us together is the duty every member of a society has to support the art that represents it. . . . Today it is no less our duty, as elected officials, as business leaders, as parents and citizens, to make our society a better place. We do that by supporting the arts."

> *"We talk a lot these days about getting back to basics. But arts education is not a frill, it is a basic. There is a lot of talk these days of bringing values back into our children's educations. Well, art may be our best way to teach those values."*

I believe New Jersey is the first state to undertake a statewide approach to arts education. I am very, very proud of our leadership in this area. We talk a lot these days about getting back to basics. But arts education is not a frill, it *is* a basic. There is a lot of talk these days of bringing values back into our children's educations. Well, art may be our best way to teach those values.

John Kennedy said that, "Art establishes the basic human truths which must serve as the touchstones of our judgment." I am not prepared to enter the ageless controversy over whether the purpose of art is to delight or instruct. For me, it is enough to say it does both. Art can reach children, as it reaches all of us, in ways that math or science cannot. Art can reinforce in our children those basic human values we hold most dear.

State government has played a major role in supporting the arts in New Jersey. But we are far from alone. Tomorrow Scott McVay and I will be at Waterloo Village, where 1,000 students and teachers from all across the state have gathered for the 3rd Annual Geraldine R. Dodge Poetry Festival. The Dodge Foundation has done a tremendous job helping young people use poetry to find their voices, and perhaps their destinies.

It will be nice to return to Waterloo. I was there in July for a performance of *Turandot,* part of the Met in the Park program, of which Chemical Bank is a prime sponsor. Right here in New Brunswick, Johnson & Johnson has spurred nothing less than a renaissance with

its generous support of, among other things, the Crossroads and George Street Theaters. AT&T, Prudential, Beneficial and Mutual Benefit Life are among the many corporations which have become the stars behind the stars when it comes to supporting the arts.

We are going to continue to move forward in New Jersey. It is said that, during the Italian Renaissance, Michelangelo looked over one of Raphael's sketches and wrote under it, *amplius,* which means "greater" or "expand." We hope to follow the master's advice by creating five regional cultural centers, spread geographically and demographically around the state, and to build one world-class arts center in our largest city, Newark.

There is no doubt in my mind that such a network of cultural centers is what New Jersey needs and deserves. Nor is there any doubt that a world-class center in Newark is the right thing to do. For all of New Jersey's leadership in supporting the arts, we can take to heart the lessons of Cleveland, Pittsburgh, Milwaukee and Charlotte in the positive impact such an arts center could have for the city of Newark and the state as a whole.

We here in New Jersey are proud of what we have become in the last several years. Our children face the happy possibility of growing up to enjoy a clean environment, good schools and a robust economy that will guarantee them a high standard of living. Our children will have their food, shelter and clothing.

But, as Emerson said, the true test of

"I am not prepared to enter the ageless controversy over whether the purpose of art is to delight or instruct. For me, it is enough to say it does both. Art can reinforce in our children those basic human values we hold most dear."

> "If we want our children to be truly civilized, truly healthy, truly happy, we must give them art to answer the hunger within."

civilization is not "the census, nor the size of the cities, nor the crops, but the kind of man the country turns out." If we want our children to be truly civilized, truly healthy, truly happy, we must give them art to answer the hunger within.

It Is the Dark We Have to Fear

Edward Albee

I think some mistake may have been made
here today. Here am I, a creative artist (if
you will forgive the term—I know it's not a
fashionable one in this country), being in-
vited to speak before an organization having
to do with the furthering of the arts in the
United States. Are you sure there hasn't been
some sort of gigantic error? If we are to judge
by the exclusionary posture or—at best—
tokenism rampant these days, I would sug-
gest that there has been. But before the error
can be acted upon, I would like to say that I
am thrilled to speak about the creative arts; I
would also like to say (before I am dragged
kicking and screaming from the platform)
that I am not an innocent in the ways of public
and private funding of the arts in the United
States today. I have sat on the council of a
major state endowment, I have done jury
duty from time to time for the National En-
dowment for the Arts (occasionally puzzled
there, I must confess, by the urging that I try
to find as many worthy playwrights from
South Dakota, say, as I would find in New
York City), I have sat on the boards of
numerous private philanthropic organiza-
tions, and I have been invited to judge my fel-

*Edward Albee is a Pulitzer Prize-
winning playwright whose
works include* The Zoo Story,
Who's Afraid of Virginia Woolf?, A
Delicate Balance, Seascape *and,
most recently,* Marriage Play. *He
serves on the New York State
Council on the Arts and is a
member of the American
Academy and Institute of Arts
and Letters and P.E.N. American.*

> *"On the continent of Africa and in other emerging areas, the creative artist is in at the birth. It is he or she who takes from the beautiful and powerful folk culture—where the differentiation between artist and artisan does not apply, and where all art is, indeed, truly useful—and, adding metaphor, creates the 'internationalization' of his or her culture."*

lows on many awards panels.

I don't know that I am the proper "creative" artist to talk to you about what it is like to be a creative artist in the United States today. My life and my career have been atypical. But before I discuss that, I would like to examine how being a creative artist in the United States today differs, and how profoundly, from being a creative artist elsewhere in the world.

On the continent of Africa and in other emerging areas, the creative artist is in at the birth. It is he or she who takes from the beautiful and powerful folk culture—where the differentiation between artist and artisan does not apply, and where all art is, indeed, truly useful—and, adding metaphor, creates the "internationalization" of his or her culture. How different from the responsibilities of the creative artist in the United States today.

Take the writer in Holland or in Finland, or in any other country where the national language is infrequently spoken elsewhere. For that creative artist to become known beyond the borders of his own land, he must write in a language other than his own, or be translated. And I am not speaking of a translation of convenience or to compensate for the lingual sloth of a society, but, rather, translation in order to exist. How different from the problems of the creative artist in the United States today.

Examine the situation of the creative artist in repressive, dictatorial or—what is the favorite Republican word for it?—

"authoritarian" societies. Indeed, what of the creative artist in these societies—be they Czechoslovakia, Chile or South Africa? What of the creative artist in these societies—or "anti-societies," to be more accurate? What of the creative artist in these societies who knows that his responsibility is to hold the mirror up to his society and let the chips fall where they may, and yet also knows that as the mirror reflects too clearly, it is he who may fall—to execution, to banishment, to prison, to madhouse, to any number of silences? In a world where a writer is declared insane for disagreeing with governmental policy, where a painter will have his work bulldozed into the earth because it is not representational, where a composer can be silenced for complexity and avant-gardism, in a world such as this, the creative artist in the United States today is a naif. And yet, and yet

The creative artist in the United States today faces problems, is under pressure from forces equally as dangerous and perhaps more insidious than those of his more obviously belabored brethren. Serious creative artists in the United States today are encouraged and in some cases almost forced to lie to the intended recipients of their talents, the goal of all their caring. They—we (let me include myself here)—we are urged to attempt the simple rather than the complex for no useful reason beyond the feeling that simple is less threatening; to tell half-truths when the truth is too unpleasant; to be pacifiers rather than disturbers; to comfort rather than stimulate; to provide "Band-Aid"

"Serious creative artists in the United States today are encouraged and in some cases almost forced to lie to the intended recipients of their talents, the goal of all their caring."

"We proceed in this society of ours on the possibly valid but untrue assumption that the public knows what it wants— that it is given sufficient information about what is available to make such a judgment. Then we jump, irresponsibly and absurdly, to the notion that there is a valid relationship between what the public wants and what it should want."

half-answers rather than pose difficult questions. By such conditions can a free society judge its aesthetic and moral health. We proceed in this society of ours on the possibly valid but untrue assumption that the public knows what it wants—indeed, that it is given sufficient information about what is available to make such a judgment. And then we jump, irresponsibly and absurdly, to the notion that there is a valid relationship between what the public wants and what it should want. And this, of course, is where you come in.

I mentioned earlier that I am not sure I am representative of the average creative artist in the United States today—by either background or career. I was adopted into a wealthy family. I received a private school education—a private *schools* education. No sooner would my well-intentioned family get me into one—Lawrenceville, for example, in Princeton, New Jersey—than I would get myself thrown out. I think it was nothing more complex than my desire to be at home and my family's desire to have me away. Well, they knew me better than I knew myself in those distant days, and I suspect they were right. I went to many, many schools. There was a law on the books, I think, in those days that said, in effect: no matter how despairing your well-intentioned family may be at your refusal to be educated, they may not have you put into a reform school. There was no law on the books, however, that said they could not do the next worse thing and put you in a military academy. And so, at the age of fourteen, for my

sins—and it is amazing the number of sins I must have committed by the age of fourteen—I found myself at the Valley Forge Military Academy, wittily located in Valley Forge, Pennsylvania.

I must be very careful what I say about this "joint"—there are spies everywhere, and where there are spies, there are lawyers. So I will phrase this carefully. It is my "memory" that they offered only two courses at the Valley Forge Military Academy: sadism and masochism. These two courses were compulsory (no electives there), and I managed to pass both, probably developing along the way a tiny preference for one over the other. No matter, I got myself thrown out of the Valley Forge Military Academy by the strategy of developing measles and chicken pox simultaneously, which puzzled them greatly. (There is mercy in the world.)

I went next to the Choate School in Wallingford, Connecticut—the only place in my life from which I have ever graduated. They taught me two things at the Choate School: how to learn to make a fool of myself in public with some grace (if you happen to be involved in the arts in the United States this is something you should learn quickly); and, even more important, that the function of a formal education is to teach you how to educate yourself once you are done with your formal education.

After Choate I went some thirty miles up the road to Trinity College in Hartford, where I lasted a year and a half. Now I, a writer from

> *"I thoroughly enjoy the fact that the creative act is constantly at war with the status quo. But our proper function as creative artists is being corrupted by a devastating misunderstanding of the purpose of the arts in our society today."*

> *"The 'common good,' however, is more complex a matter than what is merely legal. The 'common good' has to do with consciousness. And the choices that a society makes about self-education—civil, moral, and aesthetic self-education—determine its grasp on the wonders and perils of awareness, of consciousness."*

the age of six, went to college under the assumption that, axiomatically, if you are in college you are an adult, and that you should have some say as to the nature of your education.

So I arrived at college and discovered that I was expected to participate in something called "required courses." I looked at these courses and discovered that they were courses that were required *of me*—not courses that *I required*. I solved this problem, I thought, rather well: I did not attend any of the required courses. Instead, I sat in on courses that the seniors were taking—courses having something to do with my notion of how I should be educated. For the year and a half that I lasted, I was getting a very good education on the graduating level. I was, at the same time, being marked absent and therefore failing almost all of my required courses. It will tell you something about the management of Trinity College in those days that they didn't catch up with me until the middle of my sophomore year and that the then-president of the college left shortly thereafter to become president of the New York Stock Exchange.

When they did catch up with me, they invited me into their office for a discussion. I explained my point of view: as I was the one being educated, I should have some say as to the nature of my education; and they explained their point of view, which was simply that they owned the real estate and if I did not cotton to their notion of my education I could leave. Well, I did not cotton, and therefore I left. (I should add, parenthetically, that some

twenty years later they wrote me a very nice letter offering me an honorary doctorate, which I had the good sense gratefully to refuse. Five years after that they wrote me again offering me another honorary doctorate, which I thought would be churlish to refuse; but in accepting it I pointed out to them that they were correct both to have dismissed me and to be giving me the doctorate.)

I am not surprised that I had trouble with Trinity College. I think I would have had trouble at any college, because I had decided when I was very young (six, I would like to think, since that is the year before the age of reason) that I was a writer. Nonetheless, having no common sense at that age, I began by writing poetry; and I wrote poetry for twenty years, until I finally desisted. I was getting better in the sense that I can safely say that most of the poems I wrote when I was twenty-six were better than most of the poems I wrote when I was six. And, indeed, I was getting published. Poems of mine were published when I was fifteen and sixteen in tiny little West Texas literary magazines. (Twice these little magazines folded after the issue in which they published my work.) But the trouble was that, in all these years of writing poetry, I never felt like a poet; I felt like someone who was writing poetry. (Those of you who practice the craft of poetry will understand what I am talking about.)

I wrote two novels in my teens, which may be the two worst novels that were ever committed by an American teenager. I attempted the short story for many years and discovered

> *"The function of the arts is to bring order out of chaos, coherence out of the endless static, the gibberish of the stars, and to render people capable of thinking metaphorically. The arts are an essential part of public education, and without their special lucidity, the college graduate is only half a conscious soul."*

"It is useless, as things are presently set up, to expect the marriage of art and commerce in a free-wheeling capitalist society to produce anything other than mediocrity at best. The short-term stakes are too high."

that the short story and I had grave disagreements about its nature (and that the short story was probably right). I attempted the essay, but being a "creative" artist—which meant, simply, that I didn't have to be able to think in a straight line—the essay was beyond me as well.

What to do? Here I was, lurching toward the age of thirty. At twenty-eight, a lapsed poet, a failed novelist, someone incompetent in the short story and the essay. What to do? Jump off a high building or write a play. (Believe me, writing a play is far more precipitous than jumping off a high building.) I wrote a play, and it was called *The Zoo Story*. And I discovered something important to me: I discovered that I had been a playwright all of my life and hadn't been writing plays simply because I hadn't discovered it. It was a coming home to my nature. (I think the point to be made here, which distinguishes me from many of my fellow creative artists, is that when I was a very bad writer, I was rejected; and when I emerged as a somewhat better writer, I was accepted.)

My first play, *The Zoo Story*, had its world premiere in West Berlin in German, even though it was written in English in Greenwich Village; and I discovered that I was, and had been, a playwright.

I am glad to be a playwright—which is fortunate, since it is what I am (it is nice to be able to practice one's nature). I thoroughly enjoy the fact that the creative act is constantly at war with the status quo. But our proper

function as creative artists is being corrupted by a devastating misunderstanding of the purpose of the arts in our society today.

In a democracy, as I understand it, people are permitted to go their own way, enjoy themselves as they prefer, vote as short-sightedly as they desire, and pass their lives as fully involved or as emptily as they wish, so long as they don't frighten the horses and so long as they pay reasonable attention to the "common good," as phrased in law. The "common good," however, is more complex a matter than what is merely legal. The "common good" has to do with consciousness—the one thing beyond the absence of a tail that differentiates us from the other animals. Consciousness. And the choices that a society makes about self-education—civil, moral, and aesthetic self-education—determine its grasp on the wonders and perils of awareness, of consciousness.

Examine for a moment the function of art in a democratic society—especially since in a democratic society there is, or should be, no intentional governmental control of the free expression of the arts. The function of the arts is to hold a mirror up to people, to say, "This is how you are. Take a hard look; if you don't like what you see, change." The function of the arts is to bring order out of chaos, coherence out of the endless static, the gibberish of the stars, and to render people capable of thinking metaphorically. The arts are an essential part of public education, and without their special lucidity, the college graduate is only half a conscious soul. I daresay it is useless, as

> *"The function of art is to bring people into greater touch with reality; and yet our movie houses and family rooms are jammed with people after as much reality-removal as they can get."*

"I know that no one knows as much about what is useful, instructive, and valuable in the arts as does the creative artist. What I have learned from critics and lay audiences is how long my plays will run. But what I have learned from my fellow creative artists is how long my plays will matter."

things are presently set up, to expect the marriage of art and commerce in a free-wheeling capitalist society to produce anything other than mediocrity at best. The short-term stakes are too high. "Sell the people what they want. To hell with values; business runs on profit." The function of art is to bring people into greater touch with reality; and yet our movie houses and family rooms are jammed with people after as much reality-removal as they can get. Our commercial theatres are filled with people eager for the spectacle of mindless junk, while the serious plays—those that can tell us something about both ourselves and the practice of serious theatre as an art form—are to be found, in the main, in small theatres built for small audiences. The most popular books, the most popular music, the most popular television teach us nothing about what it is to be a reasoning, conscious animal.

But I don't have to go on with this litany. You know it all. You know as well as I that those responsible for the point of view of the television networks, the movie companies, the publishing houses, and the newspapers and magazines of this land are determined that a badly-informed public is best served by the absence of choice. "Don't rock the boat." The arts criticism of our most important communications outlets is carefully modulated to create a safe, middle-brow, upper-echelon mediocrity as the standard—a stale environment, where the adventurous, the thrilling, the joyous and the dangerous are seen as the enemy.

Many of you will remember Walter Kerr, a rather famous drama critic in the United States and not a bad one. Walter Kerr was a well-educated man (educated at the skirts of the Jesuits), a man whose aesthetic could be trusted (though perhaps not beyond the first third of the 20th century), a bright man, an enormously powerful critic for the late, lamented *Herald Tribune* and for the *New York Times,* and one of the most influential theater critics we have had in this country. Kerr once made a remark on public television that I believe is the essence of what I am trying to point out today. He said, "I consider it my function as a critic to reflect what I consider to be the taste of the readers of the newspaper for which I work." Here was a man creating public taste, defining aesthetic consciousness for an entire society—and considering it his responsibility to "reflect" the public taste. The public looks to the Walter Kerrs of the present day for instruction, for guidance, and all they are seeing is the reflection of their own misjudgment of the function of art.

In a democracy you cannot stop public access to that art that will most misinform the people. You cannot stop people from being misinformed. But what you can do is to educate the people to the point that they will throw the rascals out. I know, for example, that if I were given all the money on Broadway and all of its theatres to show only the finest plays of world literature for twenty years, at the end of those twenty years those plays would represent the theatre taste of our society. The American public is not hopeless;

> *"Public and private arts support organizations are capable of bringing together, far more even than they are doing now, the aesthetic education of a free society and those who can teach the best—the creative artists themselves."*

"Unless you are terribly, terribly careful, you run the danger—without even knowing it is happening to you—of slipping into the fatal error of reflecting the public taste instead of creating it."

the American public is *helpless.* I also know something else. I know that no one knows as much about what is useful, instructive and valuable in the arts as does the creative artist. In my thirty-year career as a playwright, I have never learned as much from any critic or lay audience member about the practice of my craft as I have learned from my fellow creative artists. What I have learned from critics and lay audiences is how long my plays will run. But what I have learned from my fellow creative artists is how long my plays will *matter.*

I would like to put these two points together. Public and private arts support organizations are capable of bringing together, far more even than they are doing now, the aesthetic education of a free society and those who can teach the best—the creative artists themselves. I realize that this is harder for those in the public sector (the pressures are more direct). When I sat on the council of a very rich state arts support organization, I was, out of thirty or so members, the *only* creative artist. There were many "apparatchiks" (a number of them politically powerful) and some philanthropists—but only one practicing creative artist. That state arts council does a commendable job and doubtless went on its excellent way when I was replaced by a friend of the governor. But I wonder at the glory possible to a council filled with the practicing representatives of those to be immediately aided and at how much quicker and more decisively the public would be educated.

It is not enough to fill your juries, your ad-

visory panels, with creative artists. You must put us in positions of policy control. The danger is simple, and it is this: unless you are terribly, terribly careful, you run the danger—without even knowing it is happening to you—of slipping into the fatal error of reflecting the public taste instead of creating it. Your responsibility is to the public consciousness, not to the public view of itself. The pressures on you must be considerable, but there *are* absolutes in this world. And the historical continuum of the arts shows us that there are absolutes of value in the arts. Public fashion, critical reading of public desire, economic balance sheets will not aid you in knowing these absolutes and in responding properly to them. Creative artists *will* know.

It is not enough to hold the line against the dark. It is your responsibility to lead into the light. People do not like the light—it reveals too much. But hand in hand with the creative artist, you can lead people into the wisdom that is known to all other animals: simply, that it is the dark we have to fear.

> *"There are absolutes of value in the arts. Public fashion, critical reading of public desire, economic balance sheets will not aid you in knowing these absolutes and in responding properly to them."*

The Arts and School Reform: Making the Connections

Ernest L. Boyer

I am delighted to participate in this national forum on the arts. The American Council for the Arts is one of the most vigorous and influential advocacy groups in the arts community today, and I am confident that because of your efforts, the quality of education and the arts will be enormously enriched. It is critically important that you continue to affirm not only the utility of education, but its humanity as well.

During the past few years, we have had a reform movement in education, one that has been preoccupied with competition and gaining economic advantage. But it is urgently important that we also affirm the civic, moral and aesthetic dimensions of learning for our children and create in our schools a climate that enriches and inspires the human spirit through the arts.

I, in fact, have been enormously encouraged by what I have seen happening in arts education in recent years. Several excellent reports have emerged, including the

Ernest L. Boyer is president of the Carnegie Foundation for the Advancement of Teaching. Prior to joining the foundation in 1979, he served as U.S. commissioner of education, and from 1970 to 1977 he was chancellor of the State University of New York.

> *"It is urgently important that we . . . affirm the civic, moral and aesthetic dimensions of learning for our children and create in our schools a climate that enriches and inspires the human spirit through the arts."*

provocative one from the National Endowment for the Arts. This report provides a special blend of inspiration and practicality, and it has sparked a constructive debate about the balance between theory and practice in the arts. We also have a major statement on art education from the chief school superintendents, and today, well over half the states have introduced new requirements in the arts for students in our nation's public schools.

The work of the Getty Center also should be noted. Many of you have followed with great interest the activities of this provocative institution. And you have just heard from Governor Thomas Kean of New Jersey, one of the most enlightened governors in the nation, who understands not only the essentialness of education but also the civility and inspiration of the arts.

Consider as well that the New Jersey legislature recently has created a Task Force on Literacy in the Arts. The title alone sparked a fascinating discussion during our early deliberations: What does it mean to be literate in the arts? Does it mean that students not only should receive the signal system we call the arts, but also be competent in sending aesthetic signals, too? Can one be literate with only the capacity to appreciate the arts, and not the ability to communicate meaningfully with others?

The New Jersey Task Force has a sweeping mandate: to design a curriculum for grades K-12; to propose methods of evaluation; to recommend how teachers should be trained;

and to discuss how such a program should be funded. I would like to propose a moment of silence on behalf of this commission—a silent prayer for a group that has the audacity to tackle an agenda such as this. You may hear from us in eighteen months, or you may simply get a message of bereavement.

I am suggesting that the arts in education are alive and well, but today I have another challenge to propose. I am convinced that arts educators also can contribute to the central agenda of school renewal in the nation, and I wish to touch on five issues that are, I believe, at the very heart of excellence in the nation's schools, issues that call for the insights and the inspiration of the arts.

First, *to achieve excellence, our schools must give top priority to early education.* The widely acclaimed document *A Nation At Risk* focused primarily on the upper years of schooling. And five years ago, the Carnegie Foundation for the Advancement of Teaching released a major study on the American high school. When I traveled around the country as commissioner of education, I concluded that what was happening in our secondary schools represented the point of greatest crisis in public education.

But increasingly another conviction has emerged. I am convinced that to strengthen education, the early years are transcendentally the most important since this is where the foundation for learning will be laid. I also believe that if we do not improve education in the first years of formal schooling, remedia-

"What does it mean to be literate in the arts? Does it mean that students not only should receive the signal system we call the arts, but also be competent in sending aesthetic signals, too? Can one be literate with only the capacity to appreciate the arts, and not the ability to communicate meaningfully with others?"

> *"Arts educators also can contribute to the central agenda of school renewal in the nation"*

tion later on will be exceedingly difficult to accomplish.

All of you have no doubt read that marvelous little essay by Robert Fulghum entitled "All I Ever Really Needed to Know I Learned in Kindergarten." In kindergarten, he said, he learned the following: don't hit people; put things back where you found them; cookies and milk are good for you; take a nap every afternoon; and when you go out in the world, it is best to hold hands and stick together.

I am convinced that the most profound lessons are, indeed, learned in the early grades, and it is here that some of the greatest insights are discovered. What is sad, of course, is that as we go up the academic ladder (or down the academic tunnel), we become increasingly preoccupied with the fragmentation of knowledge. The focus is less and less on integrative themes and more on the interiors of the disciplines. Slowly but surely some of the most fundamental insights of education are diminished.

Above all, to strengthen early education, we must give more status to primary school teachers. We need smaller classes, too; my general formula is the smaller the child, the smaller the class.

Further, it is in the early years when a special readiness for language exists, and small children should learn that we communicate not just verbally, but nonverbally, as well. Children, even before they become fluent in the symbol system we call words, are power-

fully affected by music and dance and the visual arts.

The arts have such a claim on early education because they encourage the empowerment of children through the use of nonverbal symbols that come naturally and are intuitively understood. So I urge the arts community to join the debate about better schooling and insist upon the essentialness of the early years. We must remind our colleagues that we need to learn not just how to read and write and spell, but how to dance and sing and paint. We must help our children give the deepest expression to the human spirit that words cannot convey. We must, in the push for school renewal, celebrate the joyful capacity of our children to communicate through the nonverbal symbol systems of the arts.

This leads me to priority number two. *To achieve excellence in the nation's schools we need a curriculum that goes beyond isolated facts and helps students to gain a larger perspective on our interdependent world.* Frankly, I am disappointed that the current reform movement has focused primarily on what *A Nation at Risk* called the "new basics." The "new basics" means another unit in science, math and English. I am not suggesting that these areas are not important; rather I am suggesting that the study of the separate disciplines does not provide an adequate education. Children not only need to know the isolated facts, they also need to see connections that bridge the disciplines and discover how ideas are connected. Without a comprehension of larger patterns, we prepare

"To strengthen education, the early years are transcendentally the most important since this is where the foundation for learning will be laid."

> *"We must remind our colleagues that we need to learn not just how to read and write and spell, but how to dance and sing and paint."*

our students not for wisdom but for a game of Trivial Pursuit.

Victor Weiskopf, when asked what gives him hope in troubled times, responded: "Mozart and Quantum Mechanics." Where in our curriculum can students discover patterns such as these? Recently, at Cape Kennedy, we had a successful space shuttle lift-off and a spectacular return to earth. While watching on television that magnificent achievement, I was intrigued by the expressions of the scientists and engineers. If I read their lips correctly, they were not saying, "Well, our formulas worked again." Rather, as the shuttle lifted successfully into orbit, smiles broke out and the scientists responded with the term, "Beautiful." A powerful technological achievement stirred an aesthetic response. Science can be a "beautiful" experience, as Einstein noted, and the sciences, the arts and the humanities are ultimately interlocked.

Further, I feel that the arts can integrate knowledge in a very special way; more than that, dance, architecture, music, painting and sculpture are universal languages that can be understood all around the world. Salvador Dali's painting *The Persistence of Memory* can be understood by everyone haunted by the notion of the passing of time. And when Picasso confronts the unspeakable agonies of war—the screams of the child, the bereft mother, the shattered home—and puts them on a huge canvas called *Guernica,* he makes a universal statement about destruction that can be understood in the heart of every human being.

Lewis Thomas said that if the century does not slip forever through our fingers, it will be because learning will have directed us away from our "splintered dumbness" and helped us focus on our common goals. This, it seems to me, can be accomplished most effectively through the insight of the arts.

Third, *when all is said and done, I am less concerned about curriculum than I am about the inspiration of teachers and their students, and to achieve excellence in our schools, we need more creativity and less conformity in the classroom.* During our two major studies at the Carnegie Foundation—one on the high school and the other on college—we found a climate of passivity among the students. And John Goodlad, in his insightful inquiry into classrooms, reported that only about 5 percent of a student's time is devoted to speaking and when students do speak up in class they ask questions about logistics, such as, "Will we have this on the test?" There is hardly any thoughtful interaction; no exchanges that match the excitement of the Socratic method.

Walt Whitman, in the opening lines of "Song of Myself" in *Leaves of Grass,* declares, "I celebrate myself." And I believe today's society is desperately in need of individuals who are able to look at the old and familiar in startling new ways—people who can, as William Faulkner phrased it in his Nobel Prize address of 1950, "make out of the material of the human spirit something that was not there before."

"Children not only need to know the isolated facts; they need to see connections that bridge the disciplines and discover how ideas are connected. Without a comprehension of larger patterns, we prepare our students not for wisdom but for a game of Trivial Pursuit."

"Dance, architecture, music, painting and sculpture are universal languages that can be understood all around the world."

If we are going to prepare students to live in an increasingly interdependent world, we need to teach them to respond with courage and certainty to life's most fundamental questions. And this is where you in the arts can make an especially powerful contribution to school renewal by helping to inspire imagination within the human spirit.

Fourth, *to achieve excellence we must find more effective ways to evaluate students.* Frankly, if there is one issue in the reform movement that I find discouraging, it is testing and evaluation. We now give tests endlessly to children; we are always pulling up the plant to see how long the root has grown. We get numbers, but we are losing sight of what it is we are trying to assess. I am suggesting that we urgently need better ways to evaluate students by focusing on the total potential of the child.

Some of you are familiar with the work of Howard Gardner, the Harvard psychologist who wrote the book *Frames of Mind.* Gardner says that we have not only verbal intelligence but intuitive, spatial, social, quantitative and aesthetic intelligences as well. How much of the assessment going on in the nation's public schools begins to identify the full spectrum of the human potential that is within every child? We impose upon our young people a paper-and-pencil test that captures momentarily the capacity to recall isolated facts, verbally arranged, and then we make judgments as to who those young people are.

It is unethical, I believe, to start judging children based only on crude instruments that simply screen potential out. Rather, we should celebrate the differences among our students and find ways to measure nonverbal skills that, in the long run, are crucial for success.

My conclusion on this point is to recommend that the arts community become actively involved in the debate about assessment. Those in the arts understand and should keep reminding us that there are other kinds of intelligences, other potentials that, in the end, may be more important to the planet earth than those revealed by the instruments we now employ.

Finally, *to achieve excellence in our schools we must serve all the students, not just the most advantaged.* Five years after *A Nation at Risk,* I conclude that the reform movement has been successful for perhaps two-thirds of our students in two-thirds of our schools. It seems to be working well for the most stable schools by setting more requirements and holding students accountable. The most advantaged students have parents who remind them of the importance of education. They can define their gratification. But in perhaps one-third of our schools— those serving the least advantaged—the reform movement is not succeeding. In these schools, we are raising standards without increasing the help and guidance to those who need it most. As a result, we will have more failure among the coming generation, and dropout rates— which now stand at almost 50 percent in many

"Today's society is desperately in need of individuals who are able to look at the old and familiar in startling new ways— people who can, as William Faulkner phrased it . . . 'make out of the material of the human spirit something that was not there before.'"

"We now give tests endlessly to children; we are always pulling up the plant to see how long the root has grown. We get numbers, but we are losing sight of what it is we are trying to assess."

of the urban areas—will exponentially increase.

During our study of large urban schools we found a sense of anonymity among the students. Most of them move facelessly from class to class, unconnected with adults and with each other. We have a youth culture that lives in isolation, and most young people both in and out of school feel unneeded, unwanted and unconnected to the larger world. Frequently they drop out because no one noticed that they had, in fact, dropped in.

I am convinced that to save urban schools, we must break them up into units of no more than four or five hundred students each. We need to provide mentors so that every high school and junior high school student is known by an adult, someone who truly cares. I am suggesting that we cannot solve the problem of inner city schools with more rules and regulations. Without overcoming the anonymity in the institution and affirming the humanity of each student, the reform movement could bring failure, not success, and the gap between the haves and have-nots will continue to expand.

James Agee said it splendidly when he wrote, "With every child who is born, under no matter what circumstance, the potentiality of the human race is born again." Those who care about the arts have a fundamental concern about the human spirit and can help to affirm the dignity of every child.

Here then is my conclusion. Art educators should participate more vigorously in the

debate about school renewal in the nation, because the arts can provide during the crucial early years a broadening of the definition of language. The arts can integrate the curriculum and help students gain perspective. The arts can bring creativity to the classroom. The arts can improve the ways in which we evaluate our students. And, above all, the arts can remind us that we must serve all students, not just the most advantaged. This, I believe, is the agenda for arts educators all across the land.

"We have a youth culture that lives in isolation, and most young people both in and out of school feel un-needed, un-wanted and unconnected to the larger world."

To Preserve the Momentum

John Brademas

I am honored to address the 1988 National Arts Convention of the American Council for the Arts, and I am for several reasons glad to be here. First, I want to salute the ACA, on whose board I am proud to sit, for exploring significant issues in the arts through research, advocacy, discussion and debate. As a legislative adviser to the arts community, publisher and sponsor of conferences like this one, ACA, in highly constructive ways, nurtures the nation's arts.

I am glad to see so many good friends— ACA leaders Eugene C. Dorsey and Milton Rhodes; Schuyler Chapin, chairman of the Independent Committee on Arts Policy; as well as someone who for ten years was my good right arm when we worked together in Congress on arts legislation, Jack Duncan. Let me also commend the distinguished public servant who chairs this convention, Governor Thomas H. Kean.

Indeed, as a New Yorker, I am pleased to visit our neighboring state, New Jersey. To speak in a somewhat self-interested way, without New Jersey the institution I am privileged to serve, New York University, would be considerably diminished, for thousands of NYU students and employees

John Brademas is president of New York University. Before joining the university in 1981, he served in the House of Representatives for twenty-two years as a congressman from Indiana.

"Legislation creating the NEA and its companion, the National Endowment for the Humanities, was probably the single most important measure ever enacted in our country in support of the life of the mind and the imagination."

and tens of thousands of our alumni live in the Garden State.

If, during my time in Congress, I was active in shaping legislation to assist the arts, I am pleased to tell you that as president of New York University for the past seven years, I continue that commitment. As some of you know, NYU, located in Manhattan, with fourteen schools and divisions that run from upper Fifth Avenue through midtown to Washington Square and down to Wall Street, is, not surprisingly, blessed with a diversity of outstanding programs in the arts of every kind.

NYU's Tisch School of the Arts is one of the nation's foremost centers for education in the performing and communications arts; Tisch film, drama and television graduates are setting a fast and highly successful pace in both Hollywood and New York.

Our School of Education, Health, Nursing and Arts Professions, popularly know as SEHNAP, offers a wide range of arts education courses and a graduate program in museum studies. Moreover, SEHNAP is the home of the new National Arts Education Research Center. This center, funded by a $1.3 million grant from the National Endowment for the Arts, is studying the most effective ways to improve arts instruction in elementary and secondary schools.

New York University's Institute of Fine Arts is, of course, the premier center in this country for the study of art history and conservation. And our Grey Art Gallery on Washington Square is as fine a gallery for the

exhibition of serious art as can be found at any university in the United States. So I speak to you today from the dual perspectives of one who for many years helped mold national policy for the arts and now leads a university with a special dedication to them.

The final reason I am glad to be with you is the opportunity you give me to say a few words about federal policy and the arts, particularly as we look to a new administration and a new decade. I should, at the outset, warn you that I intend to speak just as candidly as I like to think I did when I was on Capitol Hill.

First, let me briefly reminisce with you about what we in Washington sought to do for the arts during my own years of service in Congress. In the two decades from 1961 to 1981, five presidents of the United States of both parties—Presidents Kennedy, Johnson, Nixon, Ford and Carter—as well as both Democrats and Republicans in Congress, championed support for the arts from our national government. As you know, I was one of the sponsors of legislation that gave recognition to the importance of the arts—through the National Endowment for the Arts and other measures—and for ten years I chaired the congressional subcommittee with responsibility for these programs.

The focus of federal encouragement to the arts has, of course, been the National Endowment for the Arts, which celebrates its twenty-third birthday this year. Legislation creating the NEA and its companion, the National En-

"The law establishing the two endowments puts the case . . . succinctly: 'It is necessary and appropriate for the federal government to help create and sustain not only a climate encouraging freedom of thought, imagination and inquiry but also the material conditions facilitating the release of this creative talent.'"

> *"The deficit is certainly not, as we are all aware, the result of wild-eyed federal spending on the arts, humanities, libraries and museums."*

dowment for the Humanities, was probably the single most important measure ever enacted in our country in support of the life of the mind and the imagination.

Former NEA chairman Livingston Biddle describes the extraordinary struggle to push through such legislation in his recent book, *Our Government and the Arts: A Perspective from the Inside.* Liv reminds us of all the reasons then advanced *not* to encourage federal support of the arts. Critics of federal involvement alleged it would be unconstitutional, threaten the autonomy of artists, lead to mediocrity or simply be a frivolous waste of taxpayers' money.

But the law establishing the two endowments puts the case *for* the use of federal tax dollars for the arts succinctly:

It is necessary and appropriate for the federal government to help create and sustain not only a climate encouraging freedom of thought, imagination and inquiry but also the material conditions facilitating the release of this creative talent.

(By the way, as I have mentioned Liv Biddle's new book, let me here also draw attention to another book, to be published shortly by Duke University Press. It is entitled *Nancy Hanks: An Intimate Portrait: The Creation of a National Commitment to the Arts,* and the author is another long-time leader of the NEA, Nancy's deputy at the Arts Endowment, Michael Straight. I am sure you will enjoy reading Michael's biography.)

I was also, with my distinguished Senate colleague, Claiborne Pell of Rhode Island, author of two other measures that opened new doors to the arts. One of them, the Museum Services Act, offers, through the Institute of Museum Services, modest but invaluable grants for general operating support to museums of every kind—art, history, science and technology—and to zoos and botanical gardens. The other statute, the Arts and Artifacts Indemnity Act, provides indemnification by the federal government to protect art and other artifacts from foreign countries exhibited in American museums. Since its enactment in 1975, this program has indemnified more that 200 exhibits—including Tutankhamun, Picasso, Van Gogh, the Vatican, Alexander and the Treasure Houses of Britain—with almost no claims for loss or damage.

Let me say a few more words about the impact of these several vehicles of federal support for the arts. From the outset, the legislation authorizing the Arts Endowment makes clear that private initiatives should continue to be the principal source of money for the arts. The Arts Endowment was envisioned as a catalyst, with special Challenge and Treasury Grants requiring a match of three non-federal dollars for each federal dollar. This formula has been immensely successful in attracting private support for, and in stimulating public interest in, the arts.

In 1965, when the Arts Endowment was created, there were relatively few professional, nonprofit performing arts organiza-

"We cannot expect that states and the private sector can fill the federal funding gap in the arts, education and social services."

"According to the economist Lester Salamon, in the years between 1980 and 1987, private contributions covered only about 60 percent of the reductions in the federal programs on which charitable and nonprofit organizations rely for activities ranging from foster care to help for handicapped persons to support for the arts."

tions in the United States. In so large a country as ours, there were but 27 opera companies, 58 orchestras, 22 professional theaters and 37 dance companies. There were only seven state arts agencies.

By 1986, we had 102 opera companies, 192 orchestras, 389 theaters and 213 dance companies. And today, there is a full-time state arts agency in every state of the union.

This extraordinary growth has been accompanied by a similar explosion in audiences. For example, the annual audience for dance has risen twenty-fold over the last two decades, from one million to twenty million.

Here I must note that a recent Louis Harris poll shows a slight decrease in arts attendance since 1984. It must be obvious, however, that the arts and culture generally in the United States, stimulated by an enlightened policy on the part of the national government, blossomed and flourished after 1965.

As everyone in this room knows, since 1981, we have had a different picture, for in virtually every budget he has submitted, President Reagan, an actor, has pressed for reduced support of the arts. According to Mr. Biddle, the newly elected Reagan Administration originally planned simply to abolish the Arts Endowment. Indeed, immediately upon coming into office, Mr. Reagan did level a sweeping attack on programs to support cultural activities. Urging more private, state and local support, the new President proposed slashing funds for the two endowments in half and

urged elimination of the Institute of Museum Services.

Although Republicans and Democrats in Congress joined to reject such drastic actions, significant cuts *were* made in funds for the Arts Endowment. After 1981, for the first time in the history of the agency, the NEA budget declined. And from fiscal year 1981 through fiscal year 1987, support for the NEA stagnated, lagging far behind the rate of inflation. With inflation ballooning by over 25 percent, funds for the NEA increased by only 4 percent.

In much of their rhetoric justifying hostility toward the arts, administration leaders have contended that the arts must bear their share of bringing down the deficit. But that deficit is certainly not, as we are all aware, the result of wild-eyed federal spending on the arts, humanities, libraries and museums. Nor is it within the realm of reason to assert that state and local governments, together with private philanthropy, can make up the difference in federal cuts in money for the arts.

Let me make a few comments on this point. It is true that for the most part these other sectors have increased their contribution to the arts, and I commend state arts agencies as well as private and corporate foundations for having expanded their support for the arts. State funds for the arts, according to the National Assembly of State Arts Agencies, grew by almost 25 percent from fiscal year 1986 to fiscal year 1988, when state monies for the arts will exceed $244 million. Between 1984 and 1985, corporations, foundations

"Although Americans contributed a record number of dollars to non-profit organizations in 1987, the rate of growth of charitable giving from 1986 to 1987, was the lowest in twelve years. For the first time in almost two decades, corporate philanthropy remained level."

> *"This grim combination of federal cutbacks, harmful tax measures and increased competition for funds will further burden financially troubled arts groups."*

and individuals increased their donations to the arts and humanities by 13 percent, to a record $5 billion. But to reiterate, despite this growth, we cannot expect that states and the private sector can fill the federal funding gap in the arts, education and social services. According to the economist Lester Salamon, in the years between 1980 and 1987, private contributions covered only about 60 percent of the reductions in the federal programs on which charitable and nonprofit organizations rely for activities ranging from foster care to help for handicapped persons to support for the arts.

The Tax Reform Act of 1986 poses still other hurdles for the arts. First, to what extent will giving suffer because of the elimination of the charitable deduction for non-itemizers as well as the imposition of a minimum tax on major gifts of appreciated property? Some estimates project that the fall-off in charitable contributions for philanthropic purposes under the new law will be as much as 14 percent a year, or $11 billion. "Gifts of appreciated property are the number one way of charitable giving in the country," notes Anne Murphy, executive director of the American Arts Alliance. "Over 93 percent of all artwork in museums is the result of gifts."

A second feature of the tax law mandates a 20 percent reduction in the business deduction for tickets and other entertainment expenses. Finally, other changes under the law hurt individual artists. Unemployment compensation, on which many performing artists must from time to time depend, is now taxed.

Income averaging, which helps compensate for the frequently lean years common among artists, is no longer allowed. And under the 1986 law, artists could only deduct expenses that would go into creating a work in the year in which that work earned income. Although the IRS has changed this last portion of the code, the revised rules still remain burdensome.

And if the new provisions in the tax law threaten to harm the arts, the impact of the stock market crash and a changed business climate further endangers them. Indeed, although Americans contributed a record number of dollars to nonprofit organizations in 1987, the rate of growth of charitable giving from 1986 to 1987, was the lowest in 12 years. For the first time in almost two decades, corporate philanthropy remained level.

And the arts began to feel new constraints. A recent survey of 124 art museums by the American Association of Museum Directors found that contributions of artworks have fallen off by nearly 50 percent from 1985 to 1987.

The director of the Museum of Modern Art, Richard Oldenburg, recently said, "We're facing a basic misunderstanding of what the federal government intended to do when it set up tax incentives to nonprofit organizations. These are the ways in which the government has traditionally supported the arts." He made this point at an excellent panel discussion entitled "Cultural Crisis: The Impact of Federal Legislation on Museums and the Future of the

"Federal cutbacks fall most heavily on small and experimental arts groups directed to audiences such as rural or minority people."

> "There is also a pragmatic side to the benefits to be gained from support of the arts, namely, a highly positive economic impact."

Visual Arts," at the Guggenheim Museum, on September 26.

How did the fundraising experts explain these changes in charitable giving? "We predicted there would be some negative impact as a result of the tax act, and this appears the case," said Brian O'Connell of Independent Sector, a major philanthropic coalition. "Corporate contributions have definitely plateaued because of the restructuring of corporate America, the mergers, acquisitions, leveraged buyouts, divestitures and downsizing," said Anne Klepper of the Conference Board.

This grim combination of federal cutbacks, harmful tax measures and increased competition for funds will further burden financially troubled arts groups. Over the past several years, many arts organizations have been sliding into deficit situations. For example, half the opera companies surveyed recently were in deficit. Said David Gockley, the president of OPERA America, "Few would dispute that conditions are more hostile to a flourishing arts scene than at any time over the last 20 years."

Of course, reductions in federal support for the arts do not affect all organizations in the same way. A book by Professor Paul DiMaggio, entitled *Non-Profit Enterprise in the Arts: Studies in Mission and Constraint,* points out the unequal impact of these changes. According to DiMaggio, federal cutbacks fall most heavily on small and experimental arts groups directed to audiences such as rural

or minority people. And he observes that private patrons, foundations and corporate donors are more likely to support traditional groups rather than experimental or innovative ones, the very organizations most damaged by federal cuts.

Given these realities, the arts overall may suffer in two significant ways. First, they may lose their vitality because it is most often experimental organizations that take the risks to move the arts forward. Second, in an increasingly pluralistic society, the arts may fail to reach minority audiences, and blacks, Asians and Hispanics may be discouraged from becoming artists and performers. And I know that the issue of cultural diversity in the arts is of special concern to ACA.

Although I have been speaking of the effects of government policies on individual artists and arts organizations, I want here to remind you that such support serves a public purpose as well. For it is the arts that celebrate the vast and manifold talents of Americans and bind us together as a people over time. The historian Arthur M. Schlesinger, Jr., put this point in eloquent words earlier this year in his inaugural Nancy Hanks Lecture on Arts and Public Policy. Said Schlesinger: "If history tells us anything, it tells us that the United States, like all other nations, will be measured in the eyes of posterity not by its economic power nor by its military might . . . but by its character and achievement as a civilization."

I would add that there is also a pragmatic side to the benefits to be gained from support

> *"The success of arts advocates during these past seven-and-a-half years in fending off the most drastic attacks on the arts is an encouraging sign that there is a strong constituency in America for them."*

"With your help and that of people like you all over America, I believe we can preserve the momentum for the arts built up over the past two decades."

of the arts, namely, a highly positive economic impact. Arts groups in New York City, for example, generate $6 billion in goods and services annually.

Now if I have been critical of White House policy toward the arts, I want to say that I think Frank Hodsoll, chairman of the Arts Endowment, deserves credit for putting new emphasis on arts education. Last May, the Arts Endowment issued a report, *Toward Civilization*, calling for sweeping changes in arts education in our elementary and secondary schools. I have been heartened by this effort on the part of Mr. Hodsoll, and I also see other reasons for cautious optimism.

The success of arts advocates during these past seven-and-a-half years in fending off the most drastic attacks on the arts is an encouraging sign that there is a strong constituency in America for them. Here let me acknowledge and salute some of the members of Congress of both political parties who are leading the way. I think, for example, of such persons in the Senate as Claiborne Pell, Democrat of Rhode Island; Robert Stafford, Republican of Vermont; and Paul Simon, Democrat of Illinois. In the House of Representatives, among the most effective friends of the arts are Pat Williams, Democrat of Montana; Bob Carr, Democrat of Michigan, and Jim Jeffords, Republican of Vermont, chairman and vice-chairman, respectively, of the Congressional Arts Caucus, one of the largest caucuses on Capitol Hill; and Thomas Downey, Democrat of New York. I pay my particular respects to Congressman Sidney Yates, Democrat of Il-

linois, who, as chairman of the House Appropriations Subcommittee with jurisdiction over the Arts and Humanities Endowments, has been the single most effective legislator in protecting the endowments from crippling cuts. I have been encouraged, too, by the growing support for the arts demonstrated by the nation's governors and mayors, state legislators, and business and foundation leaders.

In addition to the ACA, we should acknowledge as well the work of such organizations as the American Arts Alliance, the American Association of Museums, the National Assembly of State Arts Agencies and the National Assembly of Local Arts Agencies. And, of course, we must salute the artists themselves, many of whom have been eloquent witnesses for the arts before Congress and in other forums.

Moreover, because I speak to you in an election season, I must observe that the presidential campaign and the prospect of a substantial change in Washington provide an unusual opportunity—and challenge—for the candidates and for all of us who care about the arts. I think it is important for the candidates to recognize that, as Louis Harris has indicated, a growing percentage of Americans favor federal assistance for the arts. According to Mr. Harris, the arts—with the environment and education—are among the few things for which Americans are willing to pay higher taxes.

Both presidential contenders have issued statements about the arts. Vice President Bush has said that he would "support the National

> *"We must broaden linkages within the cultural community. There are currently some 160 different national service organizations working on behalf of the arts. We must bring these groups into closer collaboration."*

> *"We must work to ensure funding for traditionally neglected arts groups—innovative and experimental organizations that serve neighborhood, minority and rural audiences."*

Endowment for the Arts," although he has given little indication what that support would mean. As for Governor Dukakis, you can imagine how *I*—the first native-born American of Greek ancestry ever to serve in Congress *and* a Democrat—feel about *his* candidacy! Michael Dukakis has pledged that as president, he would "bolster the National Endowment for the Arts and end the annual assault on its budget." He has also vowed to strengthen arts education and international arts exchanges, and help bring financial stability to arts organizations.

As you know, the Independent Committee on Arts Policy—a group of artists, arts administrators, scholars, critics and foundation officers—has prepared a paper identifying opportunities for presidential leadership in the arts. I understand that Schuyler Chapin will be discussing the committee's recommendations at lunch today. Let me here simply say that Schuyler and his committee have done a splendid job of framing a presidential agenda for arts policy in the next administration.

Despite the difficulties we face, I feel that we can look to the future with some hope. With your help and that of people like you all over America, I believe we can preserve the momentum for the arts built up over the past two decades.

What should we be doing? Here are a few thoughts of mine. First, we must broaden linkages *within* the cultural community. There are currently some 160 different national service organizations working on behalf of

the arts. We must bring these groups into closer collaboration.

Second, we must continue to urge state governments, individual patrons, private foundations and the leaders of business and industry to support the arts. But let me reiterate that corporations and foundations cannot be expected to *replace* the reductions in federal support for the arts. Moreover, as you and I know, as a result of an uncertain economy, many corporations and foundations are reassessing their capacity to give.

Third, we must work to ensure funding for traditionally neglected arts groups—innovative and experimental organizations that serve neighborhood, minority and rural audiences.

My fourth observation is this: you and I must make the case with our elected representatives in Washington, D.C. And what is the case? It is that the arts are essential; the arts are not something to be thrown a bone after everything else is taken care of because everything else will never be taken care of. So it will be up to each of you and those you represent to make clear that the arts matter.

What must now be obvious from the record of the National Endowment for the Arts and the other federal programs to support culture is that our national government, with modest amounts of money, without stifling bureaucratic control and without unwarranted intervention, can provide support for the arts in ways that greatly enhance the quality of American life. In this respect, I strongly urge you in each of the constituen-

> *"The arts are essential; the arts are not something to be thrown a bone after everything else is taken care of because everything else will never be taken care of."*

"I strongly urge you in each of the constituencies in which you live, in your capacities as individual citizens, to call on your United States senators and representatives to urge their support for the arts, with their voices and their votes."

cies in which you live, in your capacities as individual citizens, to call on your United States senators and representatives to urge their support for the arts, with their voices and their votes.

Moreover, when you cast your own votes in November, remember to choose a president and legislators who will best understand a relationship that, in all candor, Mr. Reagan simply has failed to comprehend. And that is the close connection between federal support for the arts and the wider public interest that they serve.

In closing, I recall for you the words of one of our greatest American presidents, Franklin D. Roosevelt: "The people of this country know now . . . that art is not a treasure in the past or an importation from another land, but part of the present life of all the living and creating peoples"

And so should you and I strive *today* to ensure that the arts continue as a vibrant part of the lives of the people of the United States.

Public Service: The Winning Edge in Business

James E. Burke

*T*he city of New Brunswick has been undergoing a successful revitalization for more than a decade, and culture and the arts have been vital ingredients of this renaissance.

From day one, when architect I.M. Pei was asked to recommend a land-use blueprint for revitalization, leaders of this transformation have shown an awareness of the importance of good design. There also has been, from the outset, recognition that the arts would help to assure the total rebirth of this community—making it a better place to live and work by refreshing the spirit, in addition to serving as a stimulus for economic growth.

The plan that Mr. Pei introduced in 1976 has now become reality, including the dream of a New Brunswick cultural center. The center already encompasses, among others, the George Street Playhouse, the Princeton Ballet, New Jersey Designer Craftsmen, Crossroads Theater and the beautifully renovated State Theater.

James E. Burke is chairman and chief executive officer of Johnson & Johnson, the world's most diversified health care company. He serves on the Policy and Planning Committees of the Business Roundtable and is a member of the Trilateral Commission and the National Commission on Public Service. He is vice chairman of the Business Council and a member of the board of directors of the Council on Foreign Relations.

> *"There also has been, from the outset, recognition that the arts would help to assure the total rebirth of this community—making it a better place to live and work by refreshing the spirit, in addition to serving as a stimulus for economic growth."*

The local environment also has been greatly enhanced by Mr. Pei's architecture, including this Johnson & Johnson headquarters building.

Johnson & Johnson wanted to create here a park-like setting that could be enjoyed by the community as well as by our employees, exemplified by the Henry Moore sculpture—draped reclining mother and baby at the front of our tower. We were aided in the selection of this piece—as well as hundreds of other works inside this building—by the Museum of Modern Art, which continues to consult with us on such acquisitions and on programs that include a lecture series on art for our employees.

As a further trigger to the release of creativity and enrichment for our employees—and for the community during receptions and other visits—we have monthly exhibits by New Jersey artists in the rotunda adjacent to this room; and several major exhibitions each year feature works that range from quilts to watercolors to photography.

A major force in improving the quality of life in New Brunswick is Rutgers University, with its many offerings in both the plastic and performing arts. Only a block away, for example, is the fine Jane Voorhees Zimmerli Art Museum, where tomorrow night you will see one of Director Dennis Cate's typically inspiring exhibitions. Many of our people frequent the Zimmerli, and I believe that it adds a very special dimension to their lives. It is because of just such enrichment that, whenever I travel

to a city for the first time, I always visit its museums.

In short, we believe that contact with, and participation in, the arts adds a dimension to life that cannot be satisfied in any other way. We think that this is true for us, for our employees and for the communities where we are situated. We are, therefore, concerned, as you are, if this process seems to be slackening.

The results of a Louis Harris poll released early this year confirmed what many of you already knew—that indeed the arts overall have had a decline in attendance, down 12 percent since 1984. The primary reason cited for not attending live arts performances (the area of greatest decline) was lack of time. This correlates with the continuing shrinkage of leisure time in this country—down to 16.6 hours per week in this latest survey, a decline of 37 percent in leisure time since 1973 and 8 percent since 1984.

Other reasons for diminishing support, as cited by survey respondents, include the high cost of tickets, transportation and parking problems, concern with security, and the high costs of baby-sitters and dining out. Since the active audience seems to be aging, it would appear that the baby boomers have spent all their money on houses and cars, and now are in danger of becoming "couch potatoes."

Some have surmised that perhaps the reduction in patronage and subscriptions is due to a diminished sense of civic responsibility among the baby-boom generation. It

> *"We believe that contact with, and participation in, the arts adds a dimension to life that cannot be satisfied in any other way. We think that this is true for us, for our employees and for the communities where we are situated."*

> *"Your challenge in seeking to upgrade corporate support and patronage in general is to convince the business community of the many benefits of forming alliances with the arts."*

has even been suggested that there is "softness" of corporate support for the arts due to lack of commitment from an emerging, new breed of chief executive officer—one who is focusing on corporate survival—to the detriment of support of the arts and other expressions of civic-mindedness. Added to the problem has been the diminution of the pool of corporate donors due to the spate of mergers and acquisitions in recent years.

Your challenge in seeking to upgrade corporate support and patronage in general is to convince the business community of the many benefits of forming alliances with the arts. As others have said, you have a number of strong arguments for support of the arts. The arts:

- improve the quality of life for all in the community;
- are an investment in our society;
- enhance a company's image among all of its publics;
- spur economic development;
- attract the best and the brightest employees, and spark their creativity; and
- help business sell more products and services.

The enlightened self-interest of business is evident. You don't have to look beyond the pioneering of American Express, which has increased business through numerous successful campaigns linked to arts causes, for which millions of dollars have been raised.

You might be aware that 30 percent of Texaco's customers are influenced in buying

Texaco gasoline because of the company's sponsorship of broadcasts of the Metropolitan Opera. Mobil Corporation has generated substantial visibility because of its "Masterpiece Theatre" patronage on public television.

There are numerous examples, but in asking businesses to support your organizations, let me suggest that you keep in mind the essential importance of public service in our enterprise system. This importance flows from a perception that the interests of business and society are the same.

I would like to advance the premise that public service is not a thing apart, but is *implicit* in the charter of every American corporation. Public service is, in truth, the corporation's very reason for being. That is what makes our enterprise system so special.

This philosophy is not singular to Johnson & Johnson, but is understood by most corporations; and it is understood *exceptionally* well by quite a few. I have evidence that suggests that those companies who organize their businesses around the broad concept of public service over the long run provide superior performance for their stockholders.

First let me offer you a quotation that crystallizes these thoughts:

"Institutions, both public and private, exist because the people want them, believe in them, or at least are willing to tolerate them. The day has passed when business was a private matter—if it ever really was. In a business society, every act of business has social consequences and

"I would like to advance the premise that public service is not a thing apart, but is implicit in the charter of every American corporation. Public service is, in truth, the corporation's very reason for being. That is what makes our enterprise system so special."

> *"I have evidence that suggests that those companies who organize their businesses around the broad concept of public service over the long run provide superior performance for their stockholders."*

may arouse public interest. Every time business hires, builds, sells, or buys, it is acting for the people as well as for itself, and it *must* accept full responsibility for its act "

That was written right after World War II by a young brigadier general who had just served as head of the small War Plants Board in Washington. His name—Robert W. Johnson. It is part of a preamble to a Johnson & Johnson document he entitled simply: "Our Credo."

Essentially, what this document does is to articulate our responsibilities to all of those in society who are dependent upon us:

- first, to our consumers—doctors, nurses, patients, and mothers who buy our products and services;
- second, to our employees whose creative energies are responsible for those same products and services;
- next, to our communities—not just where our plants and offices are, but all of the various communities we deal with, including the community of man; and
- finally, to our stockholders, who invest their money in our enterprise.

We have often been asked why we put the stockholder last, and our answer has always been that, if we do the other jobs properly, the stockholder will always be well served. The record would suggest that is the case.

These guiding principles were disseminated among our employees in 1947, and to this day they continue to help form our

everyday business and social responsibility decisions. The credo reaffirms that serving the public is what any business is all about.

That philosophy has been engendered by the founders and builders of some of our most successful American businesses.

I have long harbored the belief that the most successful corporations in this country—the ones that have delivered outstanding results over a long period of time—were driven by a simple moral imperative: serving the public in the broadest possible sense better than their competition.

In 1983, in preparing to receive a public service award from the Advertising Council, I attempted to find convincing evidence to support this contention. Since that was the thirtieth anniversary of the award, I decided to look at companies which had been in existence for at least that long and which had, at the same time, fulfilled two very rigid criteria: first, they had to have a written, codified set of principles stating the philosophy that serving the public was central to their being; and second, there had to be solid evidence that these ideas had been promulgated and practiced for *at least* a generation by their organizations.

My staff worked with the Business Roundtable's Task Force on Corporate Responsibility and the Ethics Resource Center in Washington, D.C. in compiling the list. We found 26 such companies. We then looked at the performance of these same companies in terms of profits and rewards to the stock-

"I have long harbored the belief that the most successful corporations in this country—the ones that have delivered outstanding results over a long period of time—were driven by a simple moral imperative: serving the public in the broadest possible sense better than their competition."

> *". . . socially responsible corporations outperform their competitors over the long term, and developing mutually beneficial partnerships with the arts is an excellent way to serve the public interest."*

holders over the 30-year period. We had to drop 11 companies from the 26 for lack of comparable data—Prudential because it is a mutual company with no stockholders; Levi Strauss, Johnson's Wax and Hewlett-Packard because they were private corporations 30 years ago; McDonald's because it didn't even exist—and so on. But the 15 remaining companies still delivered an impressive record.

I think you will be interested in what happened to these companies. Keeping the base year of 1953, we have updated the data several times and we now have information over a period that is approaching 35 years. These findings were updated for me again last week and here is what we found.

First, profits: these companies show a 10.3 percent growth in profits compounded over this period! That happens to be almost one-and-one-half times the growth of the gross national product (GNP), which rose 7.1 percent during the same time. To understand the effect of that difference in compound rate of growth, the GNP is now about 10 times greater; the net income of these companies is more than 27 times greater!

And what about the stockholder? If any one of you had invested $30,000 in a composite of the Dow Jones 35 years ago, it would be worth $219,916 today. If you had invested the same $30,000—$2,000 in each of these 15 companies instead—your $30,000 would be worth over $1.4 million—$1,452,279 to be exact!

The results are, at the very least, provoca-

tive. In seeking corporate support for your or-
ganizations you might want to suggest that so-
cially responsible corporations outperform
their competitors over the long term, and
developing mutually beneficial partnerships
with the arts is an excellent way to serve the
public interest.

The Nation and the Arts

Independent Committee on Arts Policy*

I am delighted and honored to present the Independent Committee on Arts Policy's presidential briefing paper, "The Nation and the Arts." I should start by saying perhaps this is the only document in recent history disproving the old saw that committees only create camels. No camel this; no camel-makers this committee, a group which came into existence about six years ago because John Booth, then on the staff of the Twentieth Century Fund, heard Arthur Schlesinger, Jr., speak at the American Academy and Institute of Arts and Letters about the lack of consistent major national attention to the safety and purpose of the arts. No slouch John Booth: the next day he was on the phone to Arthur, and the day after that some of us found ourselves sitting around a table at the Twentieth Century Fund beginning to grapple with this issue.

The more we talked, the more we realized there was not one non-agenda organization focusing on national arts matters, all of us having natural constituencies. There was no group whose sole purpose was the common artistic good.

The Independent Committee on Arts Policy is a forum for the continuing examination of policies affecting the arts. Formed in 1982, the Committee has focused its attention on such issues as international cultural exchange, artistic standards, patterns of funding, arts and education, criticism and governance, among others. Current chairman Schuyler G. Chapin, formerly general manager of the Metropolitan Opera, is dean emeritus of the School of the Arts at Columbia University and serves on the President's Committee on the Arts and Humanities.

Presented by Schuyler G. Chapin, chairman, at the 1988 National Arts Convention

> *". . . the arts must no longer be left off the national agenda."*

In short order we constituted ourselves the Independent Committee on Arts Policy— perhaps a high falutin' title but, as it turned out, a far-reaching one. We invited painters and sculptors, writers, composers, choreographers, playwrights, producers, impresarios, museum directors, arts administrators, foundation executives, critics, educators—a whole cross-section of the arts community to join us.

Over the past years we have met regularly to examine, argue and identify problems that can no longer be swept under collective rugs. Our purpose became clear: the arts must no longer be left off the national agenda. Alberta Arthurs of the Rockefeller Foundation became our president, and with such distinguished colleagues as you will find listed in our report, all of whom have been actively involved in the preparation of this document, we have already begun to catch the attention of both candidates. Needless to say, the ACA is the perfect platform to make this document public, and we are grateful for the invitation to be here today.

The Independent Committee on Arts Policy—a bipartisan group of artists, arts administrators, critics, scholars and foundation officers—has prepared this briefing paper because it believes that federal government must not be a passive trustee of the legacy that art represents, and that the next President must infuse federal arts policy with a new sense of vision.

That vision can reflect the various ways in which the arts help shape this country's na-

tional identity. It is our arts institutions—orchestras, museums, theatres, opera and dance companies, and others—that preserve and articulate the cultural legacies of past generations and enable us to carry forward the creative expressions of our forebears. It is the artists of our own day who mirror the spirit of the times and give voice to our dreams and fears, our hopes and nightmares. It is through the arts that we can better understand and appreciate the extraordinary diversity—ethnic, racial, religious—that so intensely characterizes the American experience. It is through the arts that children learn to give form and meaning to their own emerging sense of self. And finally, our place in the community of nations is enhanced by permitting the creative energies of our artists to touch the lives of peoples throughout the world.

> *". . . the next President must infuse federal arts policy with a new sense of vision."*

This paper identifies opportunities for presidential leadership in five areas in which the needs of the arts and the timeliness of federal action are joined.

The President of the United States should . . .

1. Affirm the unique role played by artists and arts institutions in our national life by addressing legislative, legal and tax issues that adversely affect them.

2. Endorse the importance of the arts in the education of the young through support of a greater federal involvement in this vital sector.

3. Promote greater access to the arts to reflect our nation's diverse cultural tradi-

> "... *our place in the community of nations is enhanced by permitting the creative energies of our artists to touch the lives of peoples throughout the world."*

tions and to respond creatively to major demographic changes.

4. Help ensure the financial stability of cultural institutions by advocating an expanded level of federal support and preserving existing mechanisms for the allocation of funds.

5. Expand support for international cultural exchange.

These measures offer the next administration the opportunity to frame the national agenda for arts policy and to influence the quality of decision-making about arts support in both the public and private sectors. Artists, arts workers, patrons, scholars and a large public believe that the moment for bold leadership is now.

The President should affirm the unique role played by artists and arts institutions in our national life by addressing legislative, legal and tax issues that adversely affect them

Much of this nation's artistic activity is reflected in work disseminated by organizations functioning in a marketplace environment. For example, the commercial theatre, the film industry, commercial art galleries, most publishing houses, recording companies, and radio and television stations operate as profit-seeking entities surviving essentially on their ability to provide an artistic "product" desired by the public.

At the same time, a rapidly growing sector of the arts community—nonprofit organizations—is responsible for preserving and com-

municating our unique cultural heritages in such art forms as symphonic and chamber music, opera, dance and the visual arts. This sector can be—and often is—the most significant domain in the arts, contributing considerably to the welfare of commercial enterprises as well. The nonprofit theatre, for instance, has evolved in recent decades into the principal home for the American playwright and the greatest nurturer of talent for commercial theatre and for the media.

For nonprofit art institutions to survive, grow and continue to serve artists and the public, the sector needs the continued support—moral, legal and financial—of the federal government. Unfortunately, pending legislation, as well as certain tax laws and rulings, is threatening the very principles on which the nonprofit community is founded. These adverse constraints are seldom intended to affect cultural institutions and individual artists, but the impact on them is dramatic and often devastating. Further, the law has often failed to extend certain needed protection to artists and their work, a fact which reinforces a perception of the artist as a second-class citizen whose role in society is not taken seriously.

Seven issues in particular stand out:

1. Congress's failure to pass laws protecting works of art from defacement or destruction, or to extend the economic rights of artists when their works are used or sold by others, leaves both art and artists open to abuse.

". . . the moment for bold leadership is now. The President should affirm the unique role played by artists and arts institutions in our national life by addressing legislative legal and tax issues that adversely affect them."

> *"For nonprofit art institutions to survive, grow and continue to serve artists and the public, the sector needs the continued support—moral, legal, and financial—of the federal government."*

2. Prohibitions that prevent artists from deducting the fair market value of donated works discourages them from making such gifts to libraries, museums, schools and other public institutions.

3. New technologies in communication, sound and image duplication, production, and distribution are being allowed to erode the rights of artists, giving control of their work to others.

4. Current rulings regarding the taxation of inventory discourage book and music publishers from issuing the works of all but the most highly marketable authors and composers.

5. Efforts to impose the Unrelated Business Income Tax on a wide range of charitable activities would impede the ability of arts institutions to generate essential revenues and would thereby limit their ability to offset deficits.

6. Proposed IRS regulations that define lobbying in the broadest terms threaten the ability of nonprofits to inform legislators about their concerns and about the needs of artists.

7. Elimination of the charitable deduction for nonitemizers as of the end of 1986 discourages contributions to the arts. This deduction should be reinstated to stimulate badly needed private sector giving.

8. Gifts of appreciated assets should not be included as a tax preference item under the alternative minimum tax, as

this loss of full deductibility has become a major disincentive to giving.

The President should endorse the importance of the arts in the education of the young through support of a greater federal involvement in this vital sector

In recent years, education has moved to the top of our national agenda. Although primary responsibility for educating the young remains with state and local governments, widespread concern over the quality of education and student achievement has given this issue a new national urgency. That sense of urgency is not limited to the traditional three Rs, but encompasses the arts as both valuable disciplines in themselves and as ways of facilitating learning in other areas. It is becoming apparent that understanding and appreciating the arts are essential aspects of educational excellence.

Bold leadership at the presidential level can help generate increased federal support for arts education programs. During the 1980s, most federal funding for arts education has been channeled through the National Endowment for the Arts. However, by 1986, the budget of NEA's arts education program was only $5.2 million. Though the NEA's recent publication of *Toward Civilization* and the development of research and other projects in the area are encouraging signs, nonetheless arts education continues to be a low federal priority. The next administration must reverse this trend at the NEA and activate interest by the Department of Education and the Nation-

" . . . the law has often failed to extend certain needed protection to artists and their work, a fact which reinforces a perception of the artist as a second-class citizen whose role in society is not taken seriously."

> *"The President should endorse the importance of the arts in the education of the young through support of a greater federal involvement in this vital sector."*

al Endowment for the Humanities in arts education as well.

Well-developed programs of making and studying art serve many functions. They help students better articulate their perceptions and shape coherent responses to their experiences. When children learn to appreciate form and color, movement and speech, when they learn the importance of fashioning their own images of the world around them, they achieve greater discipline and self-confidence.

Beyond providing students with fundamental skills, arts education enables them to experience and understand other societies. Students often form their impressions of other cultures through the arts, and that broader perspective and respect for cultural diversity should be a basic part of a child's education. The arts provide an immediate and powerful way of helping children share in the world more fully.

Further, the arts have extrinsic public value as they are increasingly important to this nation's economy. Maintaining world leadership in the production and consumption of the arts requires the underpinning of arts education competitiveness.

One of the most effective ways of learning about the arts is through the media, particularly television. The use of such a valuable teaching tool should be expanded. Public broadcasting, in particular, must be encouraged to cultivate younger audiences. Commissioning new work from leading artists that reflects the heterogeneous nature of

American life would serve to enhance the learning process and stimulate both artists and audiences.

Such issues as these suggest the wide context for arts education in American schools. At the federal level, these issues can be given strong direction and momentum within the school reform movement.

The President should promote greater access to the arts to reflect our Nation's diverse cultural traditions and to respond creatively to major demographic changes

The arts offer a powerful and positive meeting ground for America's differing cultural experience and expressions. In the arts we discover who we are and we are enabled to share that understanding with others. Recognizing the opportunities provided by the major demographic changes taking place in the United States, federal leadership can encourage the cultural expression of Latinos, Blacks, Asians, Native Americans, and other ethnic groups both by providing expanded support to indigenous organizations and by ensuring their greater access to national audiences.

Such access can be achieved through a variety of ways. Touring, for example, brings artists into communities across the country to perform works that might otherwise be unavailable. Both presenting organizations and the artists they feature must be provided the resources to reach traditional audiences, as

"Maintaining world leadership in the production and consumption of the arts requires the underpinning of arts education competitiveness."

"The President should promote greater access to the arts to reflect our Nation's diverse cultural traditions and to respond creatively to major demographic changes."

well as populations that have been underserved in the past.

Libraries and museums have expanded their traditional community roles and have become regular providers of film, videotapes, art works and other nonprint media. Their efforts to reach out to new publics must also be encouraged with adequate levels of financial support.

With ownership in the publishing industry becoming more and more concentrated, it is vital that there be sufficient outlets for literary works, particularly those that mirror the multicultural nature of American life. Unless existing mechanisms for publishing and distribution are kept viable, the vital link between writer and reader will be severely weakened.

Finally, the development of new technologies, as well as the still unrealized potential of public broadcasting, makes the widespread dissemination of cultural programming a more attainable objective. Expanding the use of electronic media to reflect the pluralistic nature of American life and to reach new audiences is essential.

The President should help ensure the financial stability of cultural institutions by advocating an expanded level of federal support and preserving existing mechanisms for the allocation of funds

One indication of the breadth of public interest in the arts has been the dramatic growth in state and local arts funding over the past two decades. For example, the combined

budgets of the 54 state and territorial arts agencies now exceed the budget of the National Endowment for the Arts. By contrast, however, since 1978 the NEA's budget has dropped by 40 percent in real-dollar terms.

This form of decentralization is, in many ways, a welcome process, which has occurred precisely *because* of federal leadership in funding the arts. The next administration, in the next necessary phase of federal leadership, must ensure that state and local funding are *additive,* not substitutive of federal support. In particular, the budget of the National Endowment for the Arts—the federal government's principal arts funding agency—must be sufficient to ensure the effectiveness of that agency, to signal the value placed on its mission, and to continue its preeminence.

Two issues related to the NEA's operations, in addition to the level of funding, require attention: the maintenance of the *Peer Review* system and the quality of *Federal Appointments.*

Peer Review. The peer panels that consider applicants for federal arts grants have been vital both to the success of the Arts Endowment and to its professional acceptance. Artists and others connected to the arts have been generous in their participation in peer review. This system must be preserved. In particular, any effort to bypass it by awarding grants directly through line-item appropriations or through mechanical formulas must be avoided; they are not in the interests of the arts or the public.

"With ownership in the publishing industry becoming more and more concentrated, it is vital that there be sufficient outlets for literary works, particularly those that mirror the multicultural nature of American life."

> *"The President should help ensure the financial stability of cultural institutions by advocating an expanded level of federal support and preserving existing mechanisms for the allocation of funds."*

Federal Appointments. In selecting members of the National Council on the Arts and the chair of the NEA, and in other federally designated appointments related to the arts, the next administration must make its selections on the basis of artistic experience and ability and must heed the recommendations of the field. Artists have a valuable contribution to make to this process and must be encouraged to do so.

The President should expand support for international cultural exchange

By encouraging the open flow of art and ideas, the next administration has the opportunity to affect the way the United States is perceived and the ways in which we perceive other countries. But for this to occur, the most entrenched obstacles to international cultural exchange will have to be met head on. Foremost has been the lack of any sustained commitment to cultural exchange at the federal level.

For the National Endowment for the Arts, this lack of commitment to cultural exchange is tied to the realities of straining a modest budget, and to the Congress' conviction that taxpayers' dollars should be spent at home. The United States Information Agency does engage in a limited way in cultural exchange, but the perception must be overcome that artists are engaged for political purposes by that agency. To add to these difficulties, unnecessary restrictions imposed by the Immigration and Naturalization Service and other agencies impede the ability of foreign artists to enter this country.

Several other impediments must also be addressed, including:

- The high cost of unsubsidized international travel and production, which can be exacerbated by fluctuations in currency values;
- The lack of adequate information on international presenting or of a database on existing materials;
- Protectionist work rules among many trade unions here and abroad;
- Limited experience and training in international exchange among presenters and artists, and the absence of leadership networks to reinforce what is known.

By becoming a vocal advocate for international cultural exchange, the next administration can create an environment in which these and other issues may be resolved. Beyond advocacy, the administration must create more coherent policies backed by greater federal resources, identify exemplary exchange models, work to develop a database on booking and touring abroad, and expand the federal indemnity program to include the performing arts.

In time, these actions will open the door to the diverse influences that benefit artists and audiences alike. Just as importantly, open exchange can begin to break down the barriers of isolationism and promote greater artistic freedom worldwide.

The Independent Committee on Arts Policy conducted a systematic investigation of

". . . decentralization is, in many ways, a welcome process, which has occurred precisely because of federal leadership in funding the arts. The next administration, in the next necessary phase of federal leadership, must ensure that state and local funding are additive, not substitutive of federal support."

> *"The peer panels that consider applicants for federal arts grants have been vital both to the success of the Arts Endowment and to its professional acceptance."*

the policy needs of artists and the arts over the last year. An extensive amount of research on twelve subject areas, plus an overview of federal support of the arts, was commissioned by the Independent Committee from leading cultural policy scholars.

This briefing paper summarizes the Independent Committee's analysis of the most pressing issues that need presidential attention. The research material, which supports our conclusions and illuminates complex areas, is available to the President, his advisors and interested parties.

The Independent Committee on Arts Policy stands ready to assist the President in addressing the policy issues described in the paper, to identify organizations and individuals who can contribute specific solutions and to be a resource of information and ideas.

Jeanne Erwin Linnes
Ruth Mayleas
Thomas Messer
Arthur Mitchell
Richard Mittenthal
Toni Morrison
Dick Netzer
Marsha Norman
Harold Prince
Lloyd Richards
Peter Schickele
Arthur M. Schlesinger, Jr.
George Segal
Susan Sontag
Saul Steinberg
Edwin Wilson
Ellen Taaffe Zwilich
Elizabeth Murfee, *Executive Director*

"The President should expand support for international cultural exchange the most entrenched obstacles to international cultural exchange will have to be met head on."

The Road Toward Civilization

Frank Hodsoll

*F*rom a national perspective, this con-
ference represents another step in a
process that began several years ago. An Arts
Endowment survey showed that in 1982, 61
percent of American adults did not attend a
single performance of classical music, jazz,
opera, theater, musical theater or ballet, or
visit a single art museum or gallery. This find-
ing—confirmed in 1985—gave impetus to
our belief that enhanced arts education
should become a high priority.

Arts education was not always a priority at
the National Endowment for the Arts. The
principal thrust of Arts Endowment programs
has been and remains encouragement and
support of artists and arts institutions. While
the Arts Endowment has supported artists-in-
residence in schools and other educational
settings since 1969, it was not until 1983 that
we began to look systematically at how we,
like the National Endowment for the
Humanities and the National Science Founda-
tion, might influence schools in *their* develop-
ment of *educational* priorities. Indeed, when
the report of an Arts Endowment task force on
arts education was brought to the National

Frank Hodsoll has served as
chairman of the National En-
dowment for the Arts since 1981.
Previously, he held numerous
positions in the State Depart-
ment, the Commerce Depart-
ment, and the Environmental
Protection Agency.

". . . in 1982, 61 percent of American adults did not attend a single performance of classical music, jazz, opera, theater, musical theater or ballet, or visit a single art museum or gallery. This . . . finding gave impetus to our belief that enhanced arts education should become a high priority."

Council on the Arts in 1978, the Council essentially made general arts education, as opposed to the training of professional artists, a secondary priority. And, when I took over the helm of the Arts Endowment in 1981, it had been proposed, in the event of overall budget cuts, that our existing Artists in Education program be suspended for a year in order to protect the Endowment's other programs. One of my very first acts at the Arts Endowment was to restore that program, and more recently to broaden it, as well as in 1987 to make education one of the principal areas of our large-grant and multiple-match Challenge Program.

Why? Because the arts the Endowment supports—virtually all of our cultural heritage and most contemporary expression—should be a part of the lives of all Americans, not just of the lives of the gifted and talented and of those who will complete four years of college. Why? Because the arts tell us, as President Reagan has said, who we are and what we can be. By telling us about the civilization of America and the civilizations that have contributed to America, these arts tell us about what it is to be American. And, if we have a more profound sense of what it is to be an American, we will be better enabled to compete with other nations as Americans—politically and economically, as well as culturally.

It is a given in the schools that all young people will be exposed to American history. Everyone agrees that it is important for all young people to have a sense of the philosophical and political origins of the Na-

tion and of the political, economic and social evolution of the Nation. But it is not a given that all will have opportunities to acquire a sense of the philosophical and cultural evolution of the Nation.

Why? Because philosophy is viewed by many as impractical. Are values impractical? Culture is viewed as entertainment or a hobby. Are our memory of the past, our communication of the present, and our projections of the future entertainment or a hobby? Growing numbers think not. Two difficult books, Alan Bloom's *Closing of the American Mind* and E.D. Hirsch's *Cultural Literacy,* remained on the best-seller list, in both hardback and paper, for over a year. The political operatives of both campaigns have tagged "values" and "literacy" as issues of concern to most Americans.

None of this is new. What will be new is a *real* attempt—beyond rhetoric as well as prime time—to incorporate the core content of the arts and humanities as basic elements of elementary, middle and secondary education. There is room for hope, as well as formidable obstacles. Americans are an optimistic people, and they are good at tackling formidable problems.

The revision and redirection of the Arts Endowment's Artists in Education Program coincided with the 1985 congressional renewal of our authorizing legislation, in which arts education was explicitly added to our mandate. We were also asked to provide a report on the subject. *Toward Civilization,*

". . . the arts . . . should be a part of the lives of all Americans, not just of the lives of the gifted and talented and of those who will complete four years of college."

". . . it is not a given that all will have opportunities to acquire a sense of the philosophical and cultural evolution of the Nation."

which we submitted to Congress in March, is the product of many hands and many minds. We are particularly indebted to an advisory committee of 29 distinguished individuals from across the country who volunteered their time and expertise. The report is now available in book form. We have called the report *Toward Civilization* because we believe that education in the arts is integral to helping our young people gain a sense of what civilization is, and how, as adults, they can contribute to it.

Our report brings together a substantial amount of information, including new unpublished data resulting from a survey jointly supported by the U.S. Department of Education and the Arts and Humanities Endowments. The survey provides some startling findings. While it has been common wisdom that the arts have been the "first to go" in school budget crunches, in fact:

- School resources devoted to the arts are rising, in terms of both time and dollars.
- There are today almost as many art and music teachers as science teachers in the schools.
- The arts appear to have a reasonable share of the school day—15 percent at the elementary level and 17 percent in junior high or middle school.
- Enrollments in arts classes appear to be increasing.
- The number of states that have enacted high school graduation requirements in the arts has grown from two to 29 since 1980.

- Curriculum guides developed by many state education agencies include materials designed to foster student's appreciation of civilization.

One might ask, if all this is true, what is the problem? The problem is there is a gap between the stated commitment and resources for arts education and what is actually happening in the schools.

- Course requirements in the arts are often cast as alternatives (e.g., "take music or art or a foreign language or computer science").
- The 15 percent of the elementary school day devoted to the arts is apt to be taught by general classroom teachers without relevant training in the arts.
- The 17 percent of the junior high/middle school day devoted to the arts is likely to focus exclusively on creation and performance, with no attempt to impart historical or aesthetic context; it is also almost entirely confined to visual art and music, with very little dance or drama and no attention to the design or media arts.
- Arts classes in high school are mostly options for the gifted and talented or for students pursuing an "academic track" to college, but even here there is little effort to place the arts in their historical context, and no common core of knowledge is taught.
- There are no readily available textbooks and related teaching materials in the arts, except for music.

"What will be new is a real attempt—beyond rhetoric . . . to incorporate the core content of the arts and humanities as basic elements of elementary, middle and secondary education."

> *". . . we believe that education in the arts is integral to helping our young people gain a sense of what civilization is, and how, as adults, they can contribute to it."*

– Specialist art and music teachers generally are not trained in art history and aesthetic theory.

I don't need to convince this audience of the importance of the arts, nor do I need to convince you of the importance of arts education. But many, who will agree that the arts should be a part of the K-12 curriculum, do not have a clear sense of why this should be so or of what it is that they want their children to get from arts instruction. It is our view that before the educators can perfect the curriculum, all of us must perfect our understanding of what we want from arts education. What do we want all our high school graduates to go on with?

We believe there are four basic reasons for education in the arts.

– The first is to give our young people a sense of their *civilization,* and of the civilizations which have contributed to ours. Simple exposure to great works is not enough. Works such as Sophocles' *Oedipus Rex,* Bach's *Mass in B-Minor,* Shakespeare's *Othello,* Picasso's *Guernica,* Duke Ellington's "Sophisticated Lady," I.M. Pei's East Wing of the National Gallery, Martha Graham's "Rites of Spring," Mario Vargas Llosa's *The Time of the Hero,* John Huston's *The Dead,* Paul Simon's rock video, "The Boy in the Bubble," and Robert Wilson's *Einstein on the Beach,* as Elliot Eisner of Stanford University has said, need to be "unwrapped" to be understood. In

unwrapping them, one achieves cultural literacy.

— The second reason is to foster *creativity*— especially in the sense of problem-solving and reasoning. This requires perspiration as well as inspiration—craft as well as invention, painstakingly hard work as well as expression.

— The third reason for arts education is to teach the means for effective *communication*—not only verbal communication, as in reading and writing and from the great works of literature, but also the non-verbal languages of music, dance, theater, design and the visual arts, and particularly the media arts. Our young people need to learn how to see and hear and how to make images for others to see and hear. This is especially vital in an age when television, whose messages are simultaneously verbal and non-verbal, has become almost co-equal with print as a principal medium of communication, at all levels and around the world.

— Finally, arts education is essential to provide a means for making wise *choices* among the products of the arts—to assess what one reads, sees and hears, so as to distinguish the good from the bad, the benevolent from the malevolent—whether in the streets or on prime time, in our cultural heritage or within the kaleidoscope of contemporary creativity.

". . . there is a gap between the stated commitment and resources for arts education and what is actually happening in the schools."

> *". . . before the educators can perfect the curriculum, all of us must perfect our understanding of what we want from arts education."*

To help our young people move in these directions and become discriminating citizens, we have developed a number of recommendations for action at the federal, state and local levels. I would like to touch upon some of them that from my perspective are especially important.

In the curriculum area, we urge state and local education authorities to define a core of subject matter in the arts which all students should be required to learn and to provide in the basic curriculum for required and optional courses to this end. We hope New Jersey's Literacy and the Arts Task Force will pave the way to progress in this state.

We think the core should include some sense of all of the arts, including particularly the all-pervasive design and media arts. We urge a curriculum balance among creation, performance, history and theory. While we do not urge that more time *per se* be allotted to the arts, we argue that the time that is allotted be spent seriously.

Since writing *Toward Civilization,* we have become increasingly concerned that some progress be made in the near term. Even if the recommendations of our report were adopted in all schools tomorrow, it would be thirteen years—the twenty-first century— before the first student had matriculated through such a course of study. It is, of course, unlikely that even one school district would adopt all of the recommendations. So we have asked ourselves what kind of instruction would ensure in high school a degree of cul-

tural literacy in the arts, no matter what arts education a student might have had before. We plan to initiate research on this so as to offer examples, or options, of what we have come to call the "fail safe" course or courses or parts of courses which would assure the average student a sense of the arts, in the same way that the required course in U.S. history that is taught in all high schools assures the average student a sense of American political, economic and social history.

Toward Civilization also offers a number of recommendations on testing and evaluation and teacher training and certification. At the national level, we have an ongoing dialogue with the national Assessment of Educational Progress. While it may be that this should not be the case, it is nonetheless a fact that the curriculum actually taught in schools often evolves from the development of the test questions. With regard to teachers, we need to strengthen the role, and the training and certification, of teachers. We will have, for example, more adequate arts education for the 15 percent of the school day allotted to it in elementary schools if general classroom teachers have had more relevant training in the arts. It is also of great importance that teachers know how to teach the history of the arts and their significance to civilization, as well as their creation and production.

Most of what we hope for in arts education must come from schools and local school districts. That is where the content of education in our country is properly decided, and that is where over 90 percent of the resources

"Our young people need to learn how to see and hear and how to make images for others to see and hear. This is especially vital in an age when television, whose messages are simultaneously verbal and non-verbal, has become almost co-equal with print as a principal medium of communication, at all levels and around the world."

> *"It is also of great importance that teachers know how to teach the history of the arts and their significance to civilization, as well as their creation and production."*

come from. Virtually everybody says arts education is important—presidents from Washington to Reagan, many governors like Governor Kean, former Secretary of Education Bennett and former Commissioner of Education Boyer, the National Education Association, the American Federation of Teachers, the National PTA, the National Conference of State Legislators (27 of 29 states with arts requirements for high school graduation have enacted them in the past eight years), the College Board, and many others. How can you be against arts education?

The problem is to translate the rhetoric into action and, more importantly, to consider arts education, like education in other subjects, as requiring serious and sequential study. No one would dream of asking a student to read Charles Dickens' *Great Expectations* without a sense of the vocabulary of Dickens. (It is sad to note that in some of our nation's schools, Dickens is no longer on the reading list because the kids lack that vocabulary.) Similarly, you cannot teach music, visual arts and design, theater, dance and the media arts without providing the students with a sense of their vocabularies. You might be able to give kids a sense of the entertainment in these arts without their vocabularies, but you don't need education to do this. There is, by the way, nothing wrong with entertainment; some of our greatest art is entertainment; but our greatest art also has other qualities.

So what are we at the Arts Endowment doing about all of this? Not a lot in terms of dollars to be sure—our FY 1989 budget for arts education is $5.6 million—higher than it has been but not enough. On the other hand, it has been shown in other areas of educational reform that federal money is not the key ingredient; consider the ineffectiveness of some of the categorical programs formerly part of the implementation of the Elementary and Secondary Education Act. Even the U.S. Department of Education spends only 6 cents out of the educational dollar; the 94 cents comes from the state and local levels.

Nonetheless, we believe the Arts Endowment can and should play a significant role. And we have begun. We are doing three things:

– *First,* we have encouraged our public partners, the state arts agencies, to build on their artists-in-residence programs and enter into a real dialogue with their state education agencies to plan for and make arts education a basic and sequential part of the K-12 curriculum. More of the states are now working with us to this end; 24 states have received Arts Endowment funds for planning, and nine states have received funds for implementation of the planning. We have also specifically asked the states to identify school districts and schools where local leadership would make progress possible. As these school districts and schools are identified, the Arts Endowment will need additional dollars to help them

"The problem is to translate the rhetoric into action and, more importantly, to consider arts education, like education in other subjects, as requiring serious and sequential study."

"Great art, and I might add great science, likewise moves beyond the adventure of its creation to provide the bulk of us, who are not capable of it, with fresh insights into the less fathomable parts of human nature"

move in this direction, and the local needs will be different in different localities.

— *Second,* we are co-funding with the U.S. Department of Education national research centers on arts education. The department, under the leadership of Secretary Bennett and his able counselor Chester Finn, included arts education research as one of the basic areas of research along with science, mathematics and elementary school subjects. The results are research centers on literature education at the State University of New York at Albany, on education in the other arts at New York University and the University of Illinois at Champaign-Urbana, and inclusion of the arts as part of the research center on elementary subjects at Michigan State University. It is our hope that the work of these centers and the development of options for a "fail safe" course or courses will add to the national menu of examples from which state and local education authorities and schools might choose.

— *Third,* we have entered into a partnership with the Getty Trust to see whether we can produce a television series on the arts for young people (ages 8-10) for home viewing. Three pilots have been completed: in the visual arts, music and dance. Much has been accomplished in these pilots, but much remains to be done. Extraordinarily innovative new television techniques have been invented and the children's

imaginations have been stirred (we have tested the pilots nationally with kids, parents and teachers); but the pilots have yet to give us confidence that the kids will leave the program with at least some of the awe of great art.

Steven Spielberg's *E.T.* is fun, but it also leaves the viewer with at least a little bit of awe for the extraterrestrial. The launching of the Discovery captured our imagination with the adventure of it, but it also left us with the awe of human beings challenging what is unknown to most of us. Great art, and I might add great science, likewise moves beyond the adventure of its creation to provide the bulk of us, who are not capable of it, with fresh insights into the less fathomable parts of human nature and of the collections of human natures which make up the city, the state, the nation and the globe.

How to do all this on television for eight- to ten-year-olds remains a mystery—it was easier in the physical world of 3-2-1 CONTACT. But we must try to pull it off, knowing that young people spend more time in front of the television set than in class.

Finally, we need to continue the movement for better arts education over a long period of time. Education will not change in America's 108,000 schools in a year, or even a decade. The Arts Endowment's own resources devoted to arts education—staff and dollars—must be strengthened over a period of at least

> *"The Arts Endowment's own resources devoted to arts education—staff and dollars—must be strengthened over a period of at least ten years in order to allow implementation of present policies and our report's recommendations to bear fruit."*

> *". . . ultimately it comes down to the American people . . . to understand why arts education is essential and then to join us in making it a priority in schools."*

ten years in order to allow implementation of present policies and our report's recommendations to bear fruit.

But ultimately it comes down to the American people—here in the State of New Jersey and in other states—to understand why arts education is essential and then to join us in making it a priority in schools. It will be the people's actions which will determine the extent to which *Toward Civilization* galvanizes progress or gains dust.

If we can make the arts a basic part of our schools, American high school graduates in the next century can be confident that, whether or not they choose to continue their formal education, they will be well equipped to engage in the creative and problem-solving process, to communicate in and understand others' communications in images as well as words, to make real choices among the products of the arts, and most important, to set out on the road toward civilization.

Let's band together to make it happen.

A Meeting of Minds

Morris Tanenbaum

I must say I am impressed with your agenda. It illustrates just how complex the issues affecting the arts have become today and how much there is to accomplish as we approach the 21st century.

I would like to begin today's session by building on your discussions of yesterday about arts and education. As a businessman educated in chemistry and physics, I suspect I will put a different spin on the subject—unless, of course, you covered the need for a stronger link between the arts and sciences, the relationship between creativity and U.S. competitiveness, and the lessons to be learned from the unseemly garden slug.

But I am getting ahead of myself. Let us begin with the rather disheartening exercise of viewing some of the problems of the U.S. educational system. Five years ago, a report called *A Nation At Risk* said that a rising tide of mediocrity in American schools threatened our very future as a nation and a people. The report stated: "If an unfriendly foreign power had attempted to impose on America the mediocre educational performance that exists today, we might well have viewed it as an act of war."

Morris Tanenbaum is vice chairman and chief financial officer of AT&T. He serves as a trustee on numerous boards, including the Philharmonic-Symphony Society of New York, the Educational Broadcasting Corporation and the Committee for Economic Development.

"There is another area that simmers just below the surface. . . . And it just might prove to be an important linchpin in our efforts to improve education. I refer to the arts and the sciences and the tenuous link between the two these days. I refer to the risk in which we put ourselves by divorcing one from the other—in our minds, if not our schools."

The report unleashed a wave of reforms. It led, for instance, to higher scholastic requirements for students *and* teachers, teacher salaries that increased, on average, at more than twice the rate of inflation, and legislation that now allows six states—including New Jersey—to take over educationally deficient schools. But as former Education Secretary William Bennett concluded earlier this year, "We're seeing progress. We're doing better. But we're not where we should be We are still at risk."

Consider the situation from my perspective as a businessman whose most important business resource is our human resource. By the end of this century—just twelve years away—it is estimated that more than half the new jobs created will probably require *more* than a high school education. In light of that fact, consider that

— Nearly one million kids in the age group sixteen years and older dropped out of public schools last year. That is a national dropout average of more than 25 percent among that group. The Hispanic dropout rate is 50 percent; it is 37 percent for blacks.

— Thousands of high school students who *do* graduate don't have the basic literacy needed to fill out a job application or to read an instruction manual.

— Eighty-five percent of the workers to be employed between now and the year 2000 already are in the workforce. Of these, 20 percent have limited skills and

are in need of remedial training in basic literacy.

- Fifty percent of all teachers will retire within the next 7 to 10 years.
 Meanwhile, fewer teachers enter the profession each year.

As business becomes increasingly global, U.S. students increasingly will be in contest with students in other countries. And here, too, is cause for concern. Consider that the average Japanese high schooler does better at math than the top 5 percent of Americans taking college-prep courses; or that when Japan's teenagers finish 12th grade, they have the equivalent of three to four *more* years of school than U.S. high school graduates.

While the U.S. illiteracy rate hovers around 10 percent, Japan's is 1 percent—and that applies to a language that covers not A through Z, but 2,000 different characters. Obviously, U.S. classrooms have not turned the corner. And I have just touched on the basics. As with most issues today, there is a web of related issues.

I am involved, for instance, with a group trying to increase the number of minority students in engineering. We have had some success—but not nearly enough. Others are focusing on issues ranging from alternative certification for teachers to learning by videotape, computer and simulation games.

There is another area that simmers just below the surface. It affects you and it affects me. And it just might prove to be an important linchpin in our efforts to improve education.

"Tomorrow's scientists and engineers need grounding in the arts to stimulate their curiosity and creativity— to help them perceive the world in new and different ways."

> *"If nothing else, a blending of the arts and sciences can cement a foundation for learning how to learn—a trait that is proving all the more crucial in a time when knowledge simply won't stay put."*

I refer to the arts and the sciences and the tenuous link between the two these days. I refer to the risk in which we put ourselves by divorcing one from the other—in our minds, if not our schools.

I have long believed that an appreciation of science and a curiosity about nature should be one of the benefits of a liberal or fine arts education. Likewise, tomorrow's scientists and engineers need grounding in the arts to stimulate their curiosity and creativity—to help them perceive the world in new and different ways.

But today there are even more utilitarian spurs for linking art and science. If nothing else, a blending of the arts and sciences can cement a foundation for *learning how to learn*—a trait that is proving all the more crucial in a time when knowledge simply won't stay put.

Technical knowledge becomes obsolete so quickly these days that lifelong learning is now the norm. And it is not just skills that need updating: whole careers can prove irrelevant almost overnight. In such fickle times, one needs an education that, in effect, urges you to assume responsibility for a lifetime's learning.

In the arts, experimentation and creativity never cease. The curators of the great museums and the music directors of the great symphonies insist on exposing their audiences to new works—often to their audiences' dismay—but often enough to stimulate their discovery of a new vision of art. Continuous

learning is the norm, and AT&T has been a supporter of such new work.

From a more important point of view, the world also needs those schooled in diverse disciplines rather than the pure technocrat or the MBA elegantly skilled in a specialty, but untutored in the ethical, social and political implications of what they do.

We live in an increasingly complex age that taunts one's sensibilities with such realities as nuclear power, test-tube babies and depleted ozone layers. And I, for one, would rather depend for solutions on the person who, by mulling over a sonnet or being emotionally moved by a symphony, has probed his conscience—and felt inherently tiny while watching the stars.

There are, of course, less esoteric reasons for cultivating the vision of the artist and the skills of the humanist. For instance, I find it refreshing, sadly only rarely so, to work with the person who can write and speak with grace and charm.

Also sadly, *I* can appreciate that *only* in the English language; but with business going global, we also find the need for a greater understanding not just of the world's languages but also of the world cultures, traditions, and histories.

That cultural diversity also applies to the U.S. workplace, which, the demographers point out, will be culturally transformed in the coming decade. Here again the arts, which speak to all cultures, offer an obvious attrac-

"The world also needs those schooled in diverse disciplines rather than the pure technocrat or the MBA elegantly skilled in a specialty, but untutored in the ethical, social and political implications of what they do."

"We live in an increasingly complex age that taunts one's sensibilities with such realities as nuclear power, test-tube babies, and depleted ozone layers. I, for one, would rather depend for solutions on the person who, by mulling over a sonnet or being emotionally moved by a symphony, has probed his conscience—and felt inherently tiny while watching the stars."

tion. At art exhibits and orchestral performances, AT&T and many other corporations find common interest with customers of all cultures and national origins. And in supporting minority artists, AT&T underscores what we have long believed—that communication is the beginning of understanding.

In the final analysis, though, the best reason for bringing the arts and sciences together might be to make learning more fun in the process. We can begin by realizing that art and science are of a piece; the methods differ but the game is the same. Or, as Arthur Koestler noted, "Newton's apple and Cezanne's apple are discoveries more closely related than they seem."

And then, if the arts can get a foot in the door, if we can stop looking at science as just so many formulas to learn or numbers to tote up, then perhaps we can get on with putting a sense of awe and wonder back into education. The popularity of the Public Broadcasting System's "Nature" series and the interest in science and the physical environment that it has stimulated in a broad audience is as much due to the beauty of its production as to its content.

Lamenting the state of science education today, Dr. Lewis Thomas has written: "It is the very strangeness of nature that makes science engrossing. But a very large number of good students look at it as slogging work to be got through on the way to medical school." He continues, "Very few see science as the high adventure it really is, the wildest of all explora-

tions ever undertaken by human beings, the chance to catch close views of things never seen before, the shrewdest maneuver for discovering how the world works."

The arts, meanwhile, are often shunted off to some academic anteroom, misdiagnosed as cultural niceties or anachronisms that have little bearing in an age ruled by science and technology. More may be at risk than simply a lack of recognition. As biochemist Robert Root-Bernstein notes, the sciences and arts compete for survival in a world as competitive as Darwin's. It is a competition based on human minds and resources—and the arts, he says, are losing.

The implications may be as grave for science as the arts. Root-Bernstein points out that the link between art and science is creativity itself. Put briefly, he believes there are in his words "tools of thought" that transcend disciplinary boundaries, skills taught only in the arts that are as important to science as they are to art.

Among these tools are playing, abstracting, building models and recognizing patterns. Nonverbal skills, for instance, that allow people, among other things, to imagine and visualize new realities before they can be proven by logic or scientific experiment.

He says, "The same 'tools of thought' that an artist needs to paint or sculpt or that a writer needs to write or a musician to compose are those which a scientist needs to discover or a technologist needs to invent. But these skills are not taught within any standard

"With business going global, we also find the need for a greater understanding not just of the world's languages but also of the world cultures, traditions and histories Here again the arts, which speak to all cultures, offer an obvious attraction."

"If the arts can get a foot in the door, if we can stop looking at science as just so many formulas to learn or numbers to tote up, then perhaps we can get on with putting a sense of awe and wonder back into education."

scientific or technological curriculum. Virtually their only source is in the arts and humanities. And here is a lever for moving the fine arts and the sciences into a position of greater harmony."

In teaching those skills, Root-Bernstein cautions that the focus should not be on what art or science *is* but *how* it is produced, focusing not on art history or theory, for example, but on art as a way of *seeing*.

Much of Root-Bernstein's work has led him to compare types of learning and innovation, to question why some scientists synthesize while others specialize, or to ask why some visualize themselves inside a situation, as when Jonas Salk pictures himself as a virus or an immune system fighting a virus.

Such questions, of course, go to the eternal quandary about how the mind arises from the brain or how, to put it more simply, people think.

Some of the answers may be dawning in today's laboratories. Scientists are studying the structure of the brain and its component parts. Biochemists are gaining understanding of the chemical processes that energize neurons, and physicists and engineers are unraveling the architecture of neural networks.

At the same time, the theories of semantics and the psychological understanding of aural and visual perception are striving to explain our abilities to see, hear and understand.

In AT&T's Bell Laboratories, studies of simple nervous systems, such as in the garden

slug, are probing the bio-electrical functions of single neurons and the animal's behavioral response to external stimuli. From such studies, practical applications are emerging. We are beginning to learn why, for instance, conventional computers are so good at number crunching but quite clumsy when it comes to recognizing a human face. We are learning that for today's computer to process information the way humans do, it will have to be much less demanding in the precision of data input and more tolerant of fuzzy data—less precisely calculating and a lot more perceptive, if you will.

But even more exciting, we are beginning to see the slow but perceptible coming together of the theories of the mind and the architecture and operation of the brain.

In a field attracting multiple disciplines—from neuroscientists to psychologists, semanticists and philosophers—we may finally link the biology of the brain to an understanding of the human mind and our psychological, philosophical and artistic perception of the world.

We are just beginning, and our progress raises profound questions. As we learn more, what effect will that have on our artistic sentiments—our ethical precepts—or on our conception of the human being's humanity? And as we learn more, should we perhaps celebrate our ignorance as much as we do our new-found knowledge?

That is one of Lewis Thomas' more intriguing suggestions for education: a cur-

"The arts, meanwhile, are often shunted off to some academic anteroom, misdiagnosed as cultural niceties or anachronisms that have little bearing in an age ruled by science and technology."

"We are just beginning, and our progress raises profound questions. As we learn more, what effect will that have on our artistic sentiments—our ethical precepts—or on our conception of the human being's humanity?"

riculum that would include courses dealing with ignorance in science. I would like to leave you with his thoughts on delighting in what we *don't* know. If we were to offer such courses, he says

"The scientists might discover in it a new and subversive technique for catching the attention of students driven by curiosity The humanists, for their part, might take considerable satisfaction watching their scientific colleagues confess openly to not knowing everything about everything. And the poets, on whose shoulders the future rests, might, late nights, thinking things over, begin to see some meanings that elude the rest of us."

"It is worth a try," he proposes. I agree.